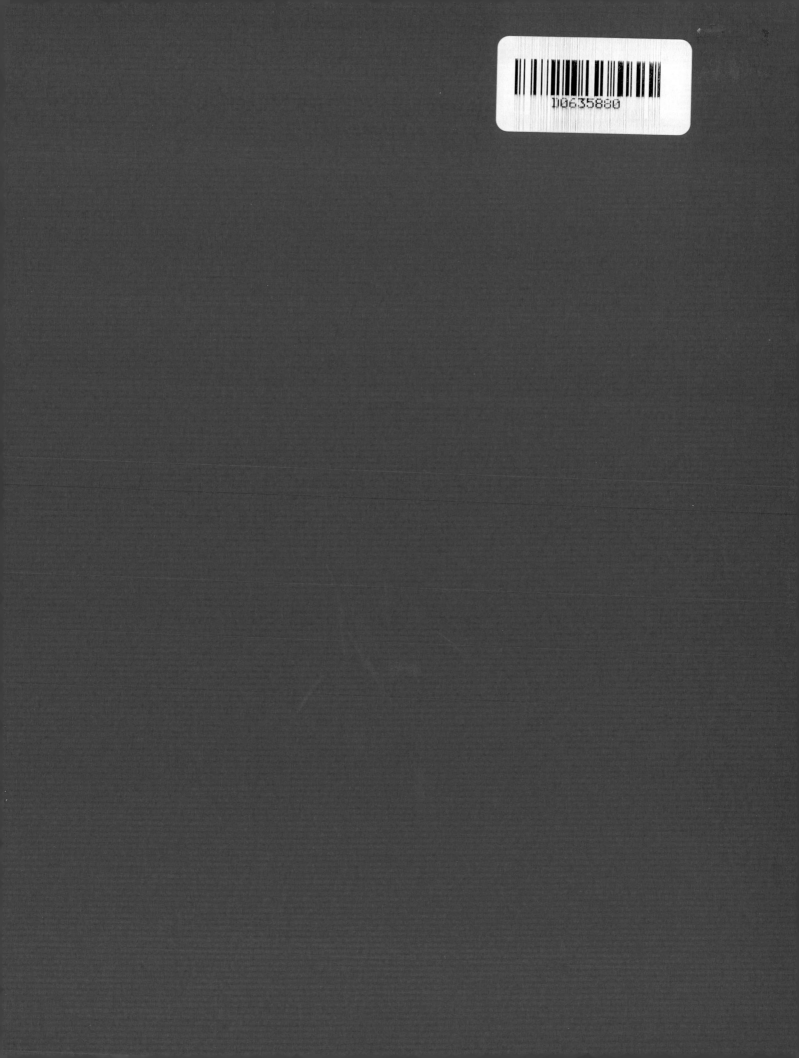

J.P. MORGAN: The Financier as Collector

J. P. MORGAN
THE FINANCIER
AS COLLECTOR

LOUIS AUCHINCLOSS

HARRY N. ABRAMS, INC., PUBLISHERS, New York

To my friend and coworker Robert Macdonald,
Director of The Museum of the City of New York

Editor: Mark Greenberg
Designer: Jacqueline Schuman
Photo Research: Uta Hoffman

Library of Congress Cataloging-in-Publication Data

Auchincloss, Louis.
J.P. Morgan: The Financier as collector / Louis Auchincloss.
p. cm.
ISBN 0-8109-3610-0
1. Morgan, J. Pierpont (John Pierpont), 1837–1913—Art collections. 2. Art—Private
collections—New York (N.Y.) 3. Metropolitan Museum of Art (New York, N.Y.) 4. Pierpont
Morgan Library (New York, N.Y.) 4. The Wadsworth Atheneum (Hartford, Conn.) 5. The
Frick Collection (New York, N.Y.) 6. The National Gallery (Washington, D.C.) I. Title.
N611.M7A95 1990 90-119 700'.92—dc20 CIP

Published in 1990 by Harry N. Abrams, Incorporated, New York
A Times Mirror Company

Printed and bound in Japan

FRONTISPIECE
Portrait of J. Pierpont Morgan, 1903
Edward Steichen
American, 1879–1973
Photograph reprinted with permission of
Joanna T. Steichen
© Edward Steichen, 1903

Contents

I JOHN PIERPONT MORGAN 7

The Financier as Collector 9

Belle da Costa Greene 18

Morgan at The Metropolitan Museum of Art 23

Morgan as a Collector 53

The Morgan Collections Come to America 67

Morgan's Last Years 79

Bishop Lawrence's Memories 85

II THE PIERPONT MORGAN LIBRARY 95

III THE MASTERPIECES 103

Gainsborough's *Duchess of Devonshire* 105

Raphael's *Colonna Altarpiece* 107

The Stavelot Triptych 110

The Illuminated Manuscripts 111

The Assyrian Slabs 127

Fragonard's *Loves of the Shepherds* 131

Two Reattributions 136

The Miniatures 139

Index 141

Photograph Credits 144

I

JOHN PIERPONT MORGAN

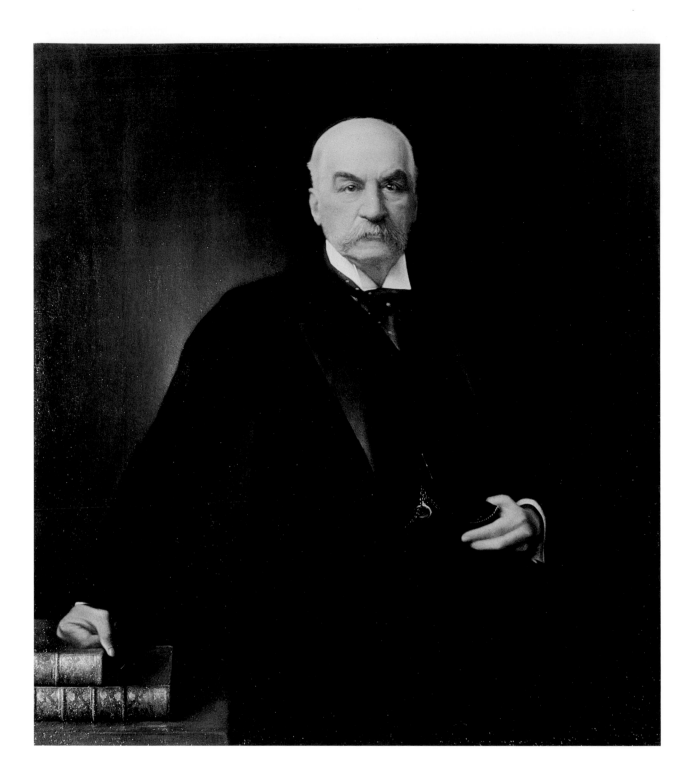

J. Pierpont Morgan
Carlos Baca-Flor
Peruvian, 1869-1941
Oil on canvas, 47 × 40 in.
The Metropolitan Museum of Art, New
York, Gift of J. Pierpont Morgan, by
exchange, 1939. 39.119

8

The Financier as Collector

HE WAS THE COMMANDING ECONOMIC FIGURE OF his age. His concept of honesty and honor, buttressed by the immense force of his character, places him aside from his fellow financiers in a kind of gaudy golden niche of his own, a shrine from which emanate the rays of a personality that could strike the observer, depending on his angle of vision, as shrewd, arcane, stubborn, arrogant, idealistic, dramatic, megalomaniac, loving, suspicious, easily hurt, and naive. I think the image he would have most liked to be remembered by is that of the massive and formidable old man, hunched over his game of solitaire in the great library gleaming with the treasures of the Renaissance, while from the antechamber the nervous captains of industry, summoned to avert the Panic of 1907, came in, one by one, each to propose his plan for saving the banks.

For where Morgan differed from other men of money was that they were concerned only for their skins while he was concerned for his and theirs. He aimed at nothing less than the creation of an orderly and prosperous business community, and he believed that capitalism was the only system that could properly accomplish this end. But capitalists had to police themselves; a sound market must depend on a gentleman's word. When Theodore Roosevelt remarked sarcastically that Morgan treated him as a peer, he was only describing literally the latter's attitude. Morgan not only considered himself the president's equal, but a greater influence for the public good. For was Roosevelt not using the Sherman Act to destroy the banker's life work? When the ex-president went on a safari to Africa, Morgan expressed the hope that the lions would do their duty.

There are some rare men, like Napoleon, who are big enough to shove history temporarily off its tracks. Morgan was not one of these. But if, as he testified to a congressional commit-

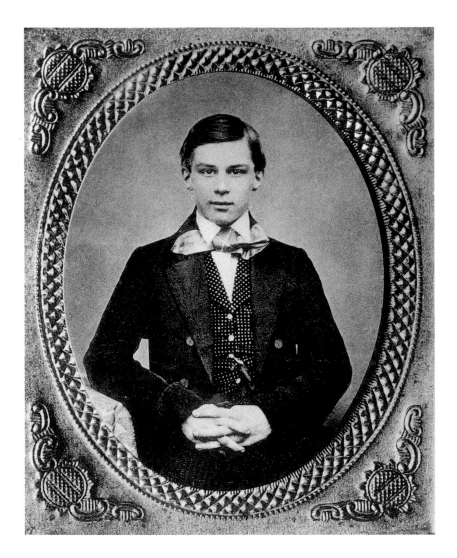

tee in 1912, only four months before his death, American finance really *had* depended on a man's character, and if more businessmen had been possessed of his own, then, indeed, the Sherman Act and the New Deal, four decades later, might not have been needed. Morgan in the end could not do it all, although his effort was a mighty one.

The one aspect of Morgan's personality about which all observers agree was that he was impressive. He had to a high degree what the military call "command presence." He considered himself a natural leader and expected to be followed. In an age of self-made tycoons he never forgot that he came of an old and honorable family, and he liked to emphasize this by choosing to live behind plain brownstone walls, disdaining as parvenu the

J. Pierpont Morgan as a Student at Vevey, ca. 1854
Daguerreotype
The Pierpont Morgan Library, New York

derivative châteaux of the Vanderbilts. It may even have been a kind of reverse snobbishness that made him go to Newport only to stay at his fishing lodge there. Yet in Europe and on his great yachts he could be as grand as the grandest aristocrat. And, of course, in surrounding himself with beautiful art he was emulating such splendid predecessors as Charles I and Cardinal Mazarin.

Behind the formidable exterior was a man of considerable simplicity, kindness, and even occasional naïveté. He was a loving and conscientious father and grandfather, and a devoted (despite an occasional lady friend) spouse. And although in a less reverent era it has been easy to smile at his passion for attending the triennial conventions of the Episcopal Church as a lay delegate and arriving at them in a private railroad car filled with bishops, his faith all his life was deep, even as glimpsed through the sentimental prose of his biographer and son-in-law, Herbert Satterlee. "The practice of hymn singing he kept up in his own home after he married. From his boyhood there were certain hymns of which he was fond, and he loved to sing them over and over again. As he grew older these hymns were associated with many of the happiest evenings of his life. And as an elderly man he sang them just as vigorously as he had done when he was a youngster, but with deeper feeling and sometimes when one of them was finished he would sit looking into the fire for several minutes without moving."

Satterlee thought that Morgan's religion even affected his collecting:

> He had no use at all for the pictures of impressionists, for "modern music" or for writers who dealt with morbid themes or social problems. Attempts at modernity or realism in those lines were absolutely distasteful to him. His spiritual faith was like the Rock of Gibraltar, and his adherence to tenets of clearly wholesome art and literature was always one of his strongest characteristics. In the great library which he left, there was no erotic literature. It was always weeded out from the collections which he bought and in the notable collection of pictures which he made there were none that he could not exhibit as fine examples of their type. Everything that he did showed clean healthy tastes and habits.

Satterlee's own knowledge of literature, at least of French

fiction, must have been inferior to his father-in-law's, for he records that among the manuscripts was that of *Nana,* with which Morgan refused to part, even when Zola's widow tried to repurchase it.

Today Morgan is remembered as much as a collector as a banker, though he did not embark on this second career, at least in a major way, until he was in his early fifties. He was born in 1837 in Hartford, Connecticut, of a long line of successful merchants. His father, Junius Spencer Morgan, succeeded as a dry-goods merchant and became a pillar of the Episcopal Church and a civic leader. His cultivated wife, the daughter of John Pierpont, the poet, may have provided a softening influence to the rather conservative mercantile atmosphere of the home. Pierpont went to a small private school in Hartford until his family moved to Boston, where his father became head of an international import-export firm and where his son was entered in the English High School, a public school of exceptionally high standards. As his biographer Frederick Lewis Allen has put it: "Thus it happened that Junius Morgan's son grew up in an atmosphere of financial security, rising business privilege and rising worldly consequence."

The earliest indication of Pierpont's interest in collecting dates from 1851 when, at age fourteen, he wrote President Millard Fillmore to obtain his autograph.

In 1852 an inflammatory rheumatism (possibly a mild polio) caused his family to send him for the winter to the warmer climate of Fayal, in the Azores. Francis Henry Taylor, a director of the Metropolitan Museum of Art, has seen in his correspondence with his parents the germ of the later collections:

> The letters also are filled with minute descriptions of the trinkets and souvenirs which he sent home as presents to his family and friends, descriptions which reveal the intensity of his observation and his love of craftsmanship for its own sake. Possibly here is the beginning of his predilection for the decorative arts which made him accumulate them later in such profusion. Neither his eye nor his taste was yet in any way developed, but already one senses his acquisitive instinct for the three-dimensional object and the article of personal and especially of historic association. Although in later life he surrounded himself with great masterpieces of painting he was always more interested in

the artifact than in the image. As The Burlington Magazine observed editorially after his death, "His feeling for works of art was the outcome rather of a romantic and historical feeling for the splendor of past ages than a strictly aesthetic one. What he recognized in an object was primarily its importance, the part it had played in the evolution of civilization."

The second move of the Morgan family, this time to London, where Junius became the partner of the great American mercantile banker George Peabody, brought an even greater change in the life of his son. Pierpont was now sent to school at the Institut Sillig near Vevey in Switzerland and two years later was enrolled in the University of Göttingen. He became fluent in German, spoke French easily, and could "get along" in Italian. In his university years he began to buy panes of ancient stained glass.

We find him in 1857, just before sailing to New York to embark on his business career, in Rome, purchasing a copy of Guido Reni's *Hope,* a "vase of oriental alabaster," and an Etruscan brooch. In Manhattan he became an accountant in Duncan Sherman & Co. on Pine Street, also acting as the personal representative of George Peabody & Co. of London. But in 1861 he fell in love with the lovely Amelia ("Mimi") Sturges, daughter of a prominent New York businessman, and he determined to marry her, despite the fact that she was fatally afflicted with tuberculosis. As Allen has said: "What happened next took him clean out of the pattern of frugal and ambitious calculation which he seemed to have been setting for himself up to this time."

Deaf to the warnings of family and friends, he gave up his business, married Mimi, and took her off to the sunny climate of Algiers in a desperate and futile effort to save her life. He returned to New York four months later, a widower of twenty-four. One should never forget this episode in Morgan's life. Can one imagine it in Jay Gould's? To appreciate fully Morgan as an art lover and patron, one must bear in mind the deeply romantic streak in his nature.

He now went into business on his own. The Civil War had started, but his poor health and fainting spells, which would almost certainly have exempted him from military service in our

time, kept him from any serious thought of enlistment. When conscription came in 1863 he availed himself of the regulation that permitted him to purchase a substitute for three hundred dollars. In 1871 he became a partner in the banking firm of Drexel Morgan & Co., which later evolved into J.P. Morgan & Co., and the rest is economic history. Until his father's death in 1890 almost all his attention was devoted to business, which is hardly surprising in view of what he accomplished.

He had, however, begun to collect. In 1864 at the Sanitary Commission Fair he is supposed to have purchased for fifteen hundred dollars the portrait of a "young and delicate woman" by one Baker, which a romantic legend ascribes to his grieving memory of Mimi. But, as Francis Henry Taylor has pointed out, the picture is dated 1874. In 1865 he formed his long and happy union with Frances Louisa Tracy and settled down to what Allen called "years of brownstone domesticity" in the northernmost region of Manhattan's residential area, around Murray Hill. He now started to put together his library of rare books and manuscripts—the manuscript of *Guy Mannering* was an early acquisition—and to buy European paintings of the sentimental academic school with such titles as *Watching the Dead Knight, The Swordsman, The Lost Sheep,* and *Alexander Pope Making Love to Lady Mary Wortley Montagu.*

Why did he wait until the age of fifty-three before starting on his major purchases? Was it just the pressure of work? A better answer seems to be that until the death of Junius Morgan (with whom he was always very close, corresponding with him daily) he did not have a fortune sufficiently vast to buy anything in the world he wanted and that he detested frustration of his cosmic aims. Now, possessed of millions, he could and would, as his wife once put it, "buy anything from a pyramid to the tooth of Mary Magdalene." The latter, an alarmingly large molar magnificently housed in a silver-gilt reliquary, is in the Metropolitan Museum.

In the next twenty-three years, right up to the time of his death, Morgan bought almost every sort of art, excepting modern and American, that one can think of: jewels; porcelains; reliquaries; Eucharist vessels; biblical scenes carved in ivory, boxwood, or rock crystal; Chinese screens; paintings and master drawings; furniture and panels; oriental carpets; tapestries; bronze and ivory statues; dress armor; Egyptian sculptures; min-

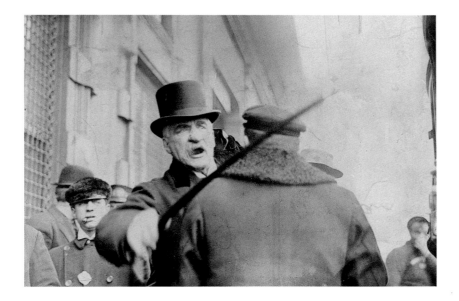

iatures of European royalty and nobles; gold medallions; gold and onyx snuffboxes—well, there was no end to it.

Can we derive a clue as to what sorts of things he most preferred in that mammoth pile? We can certainly deduce that he loved glittering, elaborately wrought pieces that had once been the baubles of monarchs; that he may have tried to reconcile his own religious faith with his greed for showy objects in the very splendor of his liturgical vessels and ecclesiastical paintings; and that, when it came to portraits, he preferred, as he did with friends, subjects that were young and beautiful. It may be worth pointing out that his passion for surrounding himself with lovely things and people increased in the last half of his life in seemingly direct proportion to the acne that so cruelly disfigured his nose and face and surely contributed to his shyness and to the brusqueness of his manners.

How good was his taste? It is hard to tell in a man who bought whole collections, who was willing to purchase a vitrine of *objets de vertu* to obtain a single piece. But nothing sharpens the eye like expensive mistakes, and Morgan was a skilled merchant who was heavily engaged in the purchase of art for a quarter of a century. Certainly the quality of his things now in The Metropolitan Museum of Art, the Pierpont Morgan Library, and the Wadsworth Atheneum in Hartford is of the highest, and to duplicate the entire collection that he left in 1913 might break a bank even in Tokyo.

Of course, he was hounded by dealers, by anyone with an artifact to sell. People studied the card games that he played; there was even a course offered in them. The Munich dealer A.S. Drey would tell the story of how, learning on a visit to New York that Morgan, then in Florence, had just bought Ghirlandaio's *Giovanna Tornabuoni*, caught a liner to Cherbourg, boarded the night train to Florence, and took up a watchful post every day for three weeks in the refectory of the Ognissanti before Ghirlandaio's fresco of the Last Supper. His theory was that any man who had bought one of the master's works would be bound to come to see his greatest. And surely enough one day Morgan strolled in, and Drey was able to engage him in conversation, as a supposedly unknown fellow tourist, on the subject of the fresco. The chat led to their dining together and to a sale by Drey in six figures.

But most of the purchases were made in less spectacular fashion. Francis Henry Taylor has described the more usual procedure. Miss Belle Greene would bring to Morgan's attention matters requiring a decision. "The letters were placed in front of him and in his own hand he would write on them marginal comments and instructions, or he would tell Miss Greene orally what he wanted done. These letters, in French, German, and Italian, as well as in English, had clearly been read by him and had been fully understood. From these instructions Miss Greene would write the replies. Virtually never would Morgan write directly; he much preferred the interposition of his trusted amenuensis."

If Belle Greene, however, on one of her buying trips to Europe, cabled a recommendation that a book or manuscript be purchased, it was not necessary for her boss to inspect the item. The librarian on whose taste and acumen he relied with such trust and who was to continue at her post for a quarter of a century after his death is almost as much identified with the Pierpont Morgan Library as the founder himself.

Reliquary Monstrance with Tooth of Saint Mary Magdalene
Monstrance: prob. Florence, late 15th c.
Medallion: Tuscany, mid-14th c.
Copper gilt, silver gilt, rock crystal and verre églomisé, H. 22 in.
The Metropolitan Museum of Art, New York, Gift of J. Pierpont Morgan, 1917.
17.190.504

Belle da Costa Greene

BELLE DA COSTA GREENE WAS BORN IN 1883 OF A cultivated but impoverished family in Richmond, Virginia. Her mother, separated from her father, moved to Princeton, New Jersey, where she supported five children by giving music lessons. Belle could not afford to go to college, but after school she went to work in the Princeton University Library, working in cataloguing and at the reference desk. Soon, however, she managed a transfer to the rare book room where she was able to cultivate what was to be a lifelong passion for old editions, manuscripts, and incunabula. It was also there that she attracted the attention of Junius Spencer Morgan, nephew of J.P., who recommended her to his uncle, whose librarian she became in 1905, at the age of twenty-one.

She and Morgan hit it off at once, and her entry in *Notable American Women, 1607–1950* records: "By 1908 she was undertaking errands for him abroad. Dealers opened their best treasures, aristocratic houses welcomed her as a guest. Belle for her part did not hesitate to adopt the grand manner that she felt suited to her role. For hotels she chose Claridge's in London and the Ritz in Paris, for clothes the foremost couturiers."

Lawrence Roth analyzed her rare capacities in this way: "To the happy task of acquisition Miss Greene has brought two highly individual characteristics—a sense of cultural values which disregards with certitude the unimportant in art or letters and an instinct for the authentic, a feeling for realness, a recognition of quality which can be likened to the possession of absolute pitch in a musician."

Her successor at the Morgan Library would describe his amazement "as he picked up book after book and found upon their fly leaves annotations in her firm, distinctive and beautifully clear writing, comprising bibliographical references, rec-

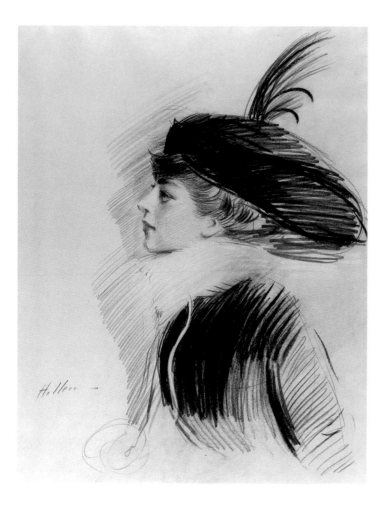

Belle da Costa Greene
Paul Helleu
French, 1859–1927
Pencil and charcoal on paper
The Pierpont Morgan Library, New York

ords of verbal comments by scholars, or pointed questioning of everything previously said on the subject of the work in hand." And yet she was never like the conventional librarian, gliding, rubber-heeled, with finger to lips, among tables and shelves. Her work, on the contrary, to quote Roth again, was carried on "heartily, noisily, in a whirl of books and papers, disturbing to one who could not perceive the cosmic orderliness of purpose which underlay the surface confusion."

We see her less charitably through the eyes of a fellow librarian of her own sex, Margaret Bingham Stillwell:

Belle Greene had two personalities, as different as night from day. In evening dress, she had grace and charm and often an intense femininity. But in the daytime she was masculine. She would stride about in a tweed suit, throwing colorful remarks offhand over her shoulder. Or, with her jacket removed she would stand belligerently while she

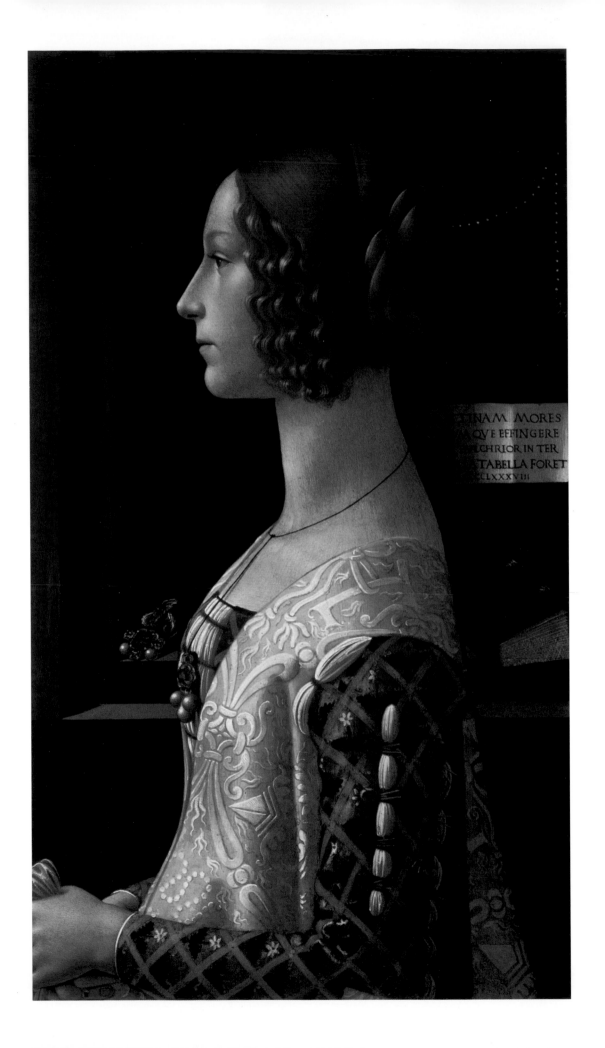

talked with you, forever poking her blouse into her skirt, which always seemed a bit too large at the waistline. She was fearless in the auction room and determined in the bookshops. When Mr. Morgan commissioned her to secure some treasure for his collection, she did. That was a foregone conclusion. She expected to get it. Morgan expected her to get it. And so did everyone else—except perhaps for a time, her poor opponent.

When Morgan died, she was overcome. "He was almost a father to me," she wrote to a friend. "His never-failing sympathy, his understanding and his great confidence and trust in me, bridged all the difference in age, wealth and position."

J.P., Jr., Morgan's son, was at first reluctant to continue adding to the library's collection, but he changed his mind, very likely in part at Belle's persuasion, and in 1924 it was incorporated, with her as director, a post that she held until her retirement in 1948.

Portrait of Giovanna Tornabuoni
Domenico Ghirlandaio
Italian, 1445–1494
Oil on panel, 30¼ × 19¼ in.
Thyssen-Bornemisza Collection,
Lugano, Switzerland

The Morgan Cup
Roman Empire, prob. Italy, 1st c. B.C. to 1st c. A.D.
Transparent blue and opaque white glasses, blown, cased, wheel-cut, engraved, H. 2⁷⁄₁₆ in.; D. (rim) 3 in.
The Corning Museum of Glass,
Corning, New York, Gift of Arthur A. Houghton, Jr. 52.1.93

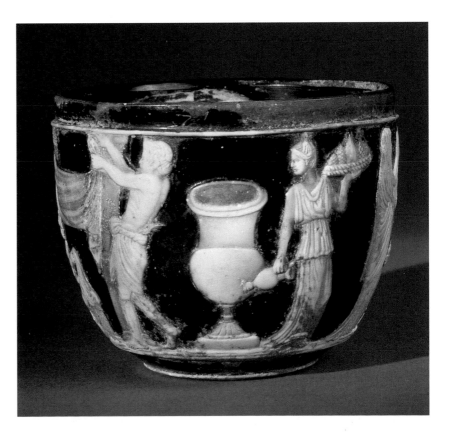

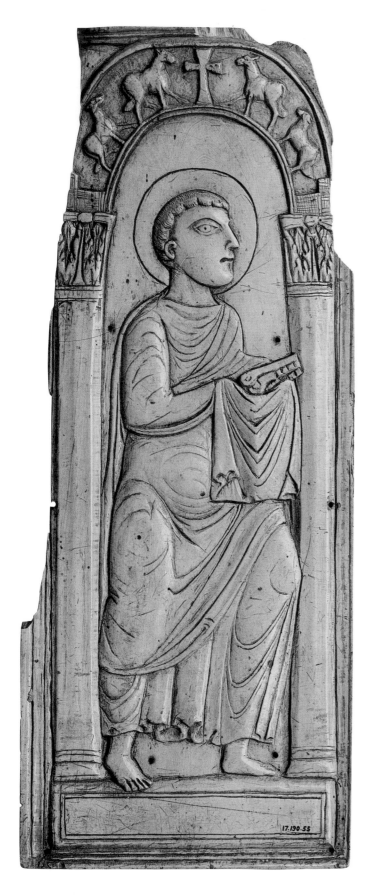

Morgan at The Metropolitan Museum of Art

Saint Peter and *Saint Paul*
Leaves of a diptych
Early Christian, prob. Gallic, 5–6th c.
Ivory, each: 11½ × 4½ in.
The Metropolitan Museum of Art, New York, Gift of J. Pierpont Morgan, 1917.
17.190.54,55

A NOTABLE EXCEPTION TO THE NORMALLY COR-dial relations that existed between Morgan and his counselors was his bad rapport with Roger Fry, the English art critic who in 1905 was advising both Morgan and the Metropolitan Museum in the purchase of paintings. Morgan had become a trustee of the museum in 1888 and chairman of the board in 1904. Fry resented Morgan's omnipotence with the board and staff and thought little of his taste; the more he saw of him the more difficult he found it "to dance to his tune." When Virginia Woolf wrote her life of Fry in 1940 she quoted from a diary in which he had made some uncomplimentary entries about his former employer.

Fry relates how Morgan became intrigued by a large seventeenth-century crucifix, not in itself a remarkable work of art, when the dealer showed him a concealed stiletto that could be whipped out of the shaft of the cross. "Shows what the fellows did in those days!" Morgan exclaimed. "Stick a man while he was praying! Yes, very interesting." Fry's comment on this remark, often quoted in books on Morgan, is sufficiently devastating: "For a crude historical imagination was the only flaw in his otherwise perfect insensibility."

But to Fry, herald of the Post-Impressionist school, the dominating presence of a man who could afford to buy all the beautiful things in the world without anything like the keenness of Fry's vision, and who lacked the smallest interest in any of the wonderful canvases that were being painted in his own day, must have been galling indeed. It should also be pointed out that Fry described the incident *after* he had been dismissed from his post at the Metropolitan at Morgan's insistence in a dispute over a painting that Fry wished to buy for the museum and that Morgan wanted for his own collection.

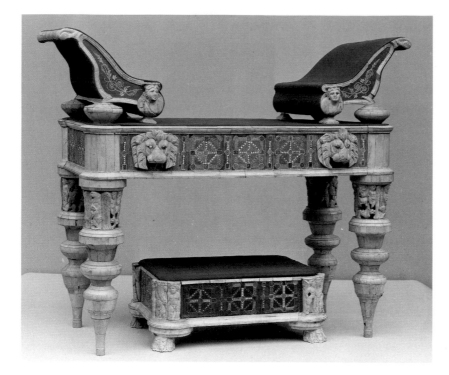

Fry was not the first curator and art historian to undervalue the role of the trustee-benefactor in the development of an art museum. Morgan was undoubtedly arrogant and dictatorial at the Metropolitan, as he was with other organizations that he brilliantly and often impatiently managed, but this has to be balanced with what he accomplished.

When he became president in 1904, the museum was clearly becoming a great art gallery, but it was still a long way from its goal. Due primarily to trustee Henry Marquand, it possessed a few masterpieces by seventeenth-century Flemish painters. It also had a mob of white plaster casts; a clutter of popular Paris salon paintings; a fine collection of 650 Old-Master drawings, the gift of Cornelius Vanderbilt II, who had acquired them from that unrecognized (in his lifetime) collector genius James Jackson Jarves (Vanderbilt also gave Rosa Bonheur's *Horse Fair*); and the Greek and Cypriot antiquities purchased by the museum's first director, the colorful Italian general Palma di Cesnola, who had found archaeology more engaging than warfare.

Morgan assumed virtual control of the staff as well as the board and expanded the collections in almost every field of art.

Couch and Footstool
Roman, 1st c. A.D.
Inlaid with bone carving and glass
Couch: 42 × 73½ × 23½ in.
Stool: 9½ × 26½ in.
The Metropolitan Museum of Art, New York, Gift of J. Pierpont Morgan, 1917. 17.190.2176 a,b

A Lady Writing, ca. 1665
Johannes Vermeer
Dutch, 1632–1675
Oil on canvas, 17¾ × 15¾ in.
The National Gallery of Art, Washington, D.C. Gift of Harry Waldron Havemeyer and Horace Havemeyer, Jr. 1962.10.1

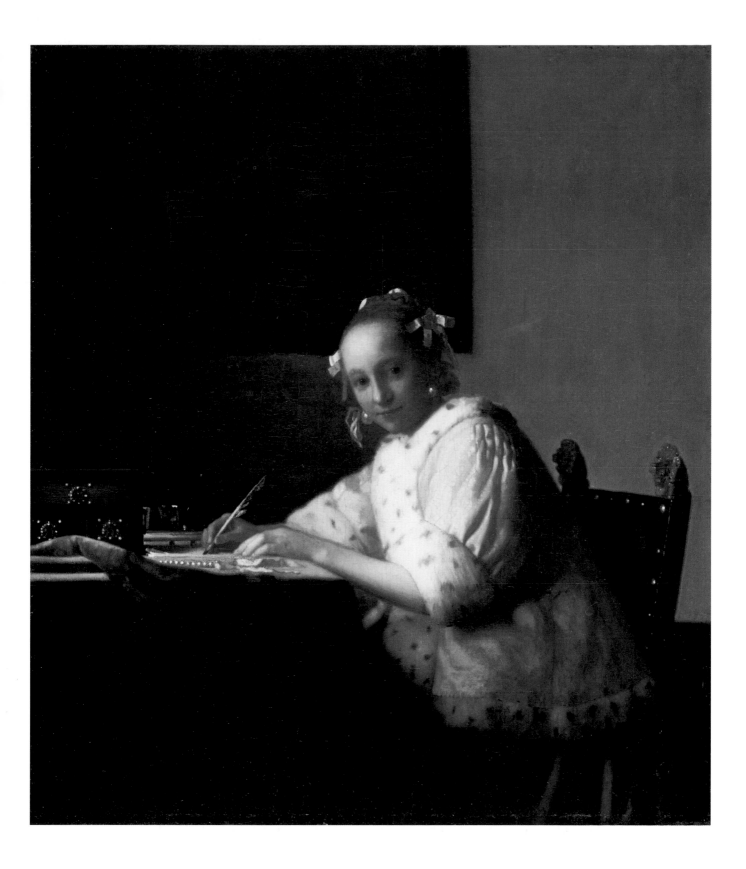

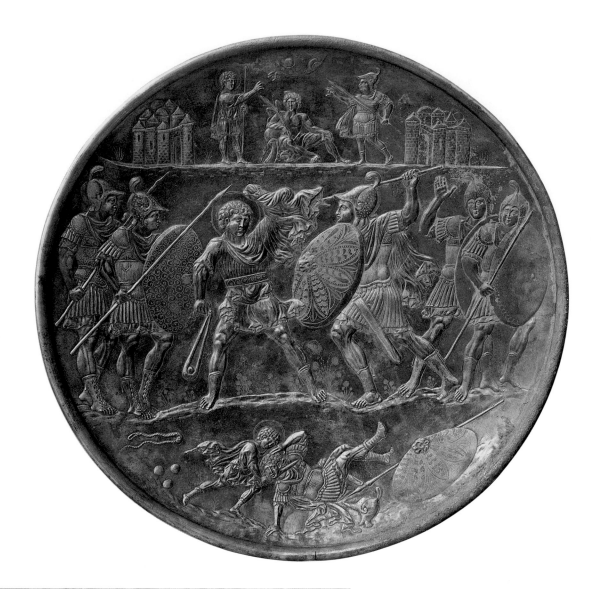

David's Battle with Goliath
Byzantine, 610–630
Silver, D. 19½ in.
The Metropolitan Museum of Art, New
York, Gift of J. Pierpont Morgan, 1917.
17.190.396

Angels with the Virgin at the Tomb
Leaf with miniature on each side
Armenian, 11th c.
Parchment, 7½ × 11½ in.
The Metropolitan Museum of Art, New
York, Deposited by Dr. John C.
Burnett, 1957. 57.185.3 recto

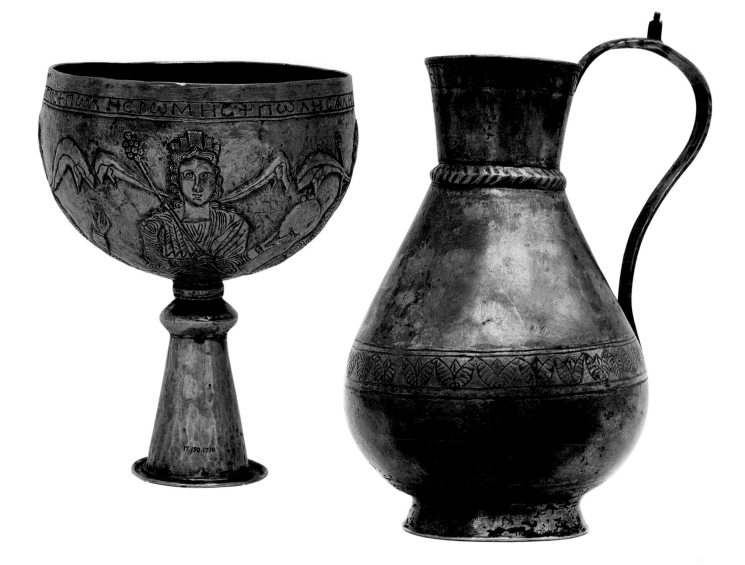

Chalice with Personification of Rome
Byzantine, prob. Cyprus, first half 7th c.
Gold, 6⅝ × 4¹³⁄₁₆ in.
The Metropolitan Museum of Art, New
York, Gift of J. Pierpont Morgan, 1917.
17.190.1710

Ewer of Zenobius
Byzantine (found in Dalmatia, near
Durazzo and Tirana), 7–9th c.
Silver and silver gilt, H. 9³⁄₁₆ in.
The Metropolitan Museum of Art, New
York, Gift of J. Pierpont Morgan, 1917.
17.190.1704

He gave and loaned his own things on a splendid and sometimes
confusing scale; curators were not always sure when Morgan was
buying for himself and when for the museum. Indeed, he seems
not always to have made the distinction very clearly, but the
museum was the ultimate beneficiary.

Aileen B. Saarinen has described Morgan at the Metropoli-
tan in *The Proud Possessors:*

As its president, Morgan ruled the Metropolitan as auto-
cratically and as bent on its success as if it were one of his
industrial corporations. He staffed it with the best experts
he could find—and then used them as his personal ad-
visers. He studded the board with millionaire businessmen
of his own kind—men like George F. Baker, Henry Clay

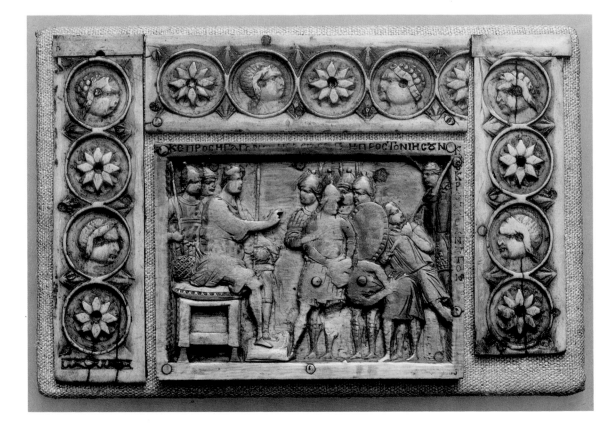

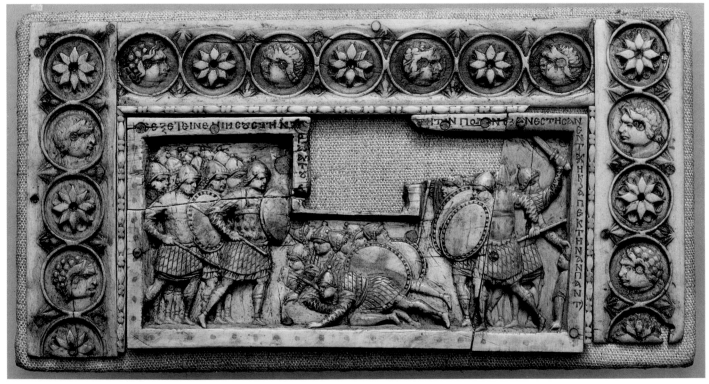

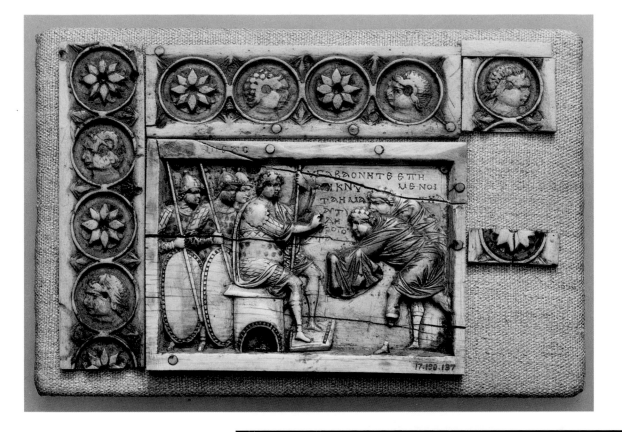

◁ *Casket Plate: Joshua Condemning to Death Adoni-Zedec, King of Jerusalem*
Byzantine, Constantinople, 10th c.
Ivory, 3¾ × 5⅝ in.
The Metropolitan Museum of Art, New York, Gift of J. Pierpont Morgan, 1917.
17.190.136

◁ *Casket Plate: Joshua Overwhelming the Army of the Canaanites at Ai*
Byzantine, Constantinople, 10th c.
Ivory, 3¾ × 7½ in.
The Metropolitan Museum of Art, New York, Gift of J. Pierpont Morgan, 1917.
17.190.135,

Casket Plate: Joshua Receiving the Ambassadors of Gideon
Byzantine, Constantinople, 10th c.
Ivory, 3¾ × 5⅝ in.
The Metropolitan Museum of Art, New York, Gift of J. Pierpont Morgan, 1917.
17.190.137

The Virgin and Saint John
Byzantine, 11–12th c.
Plaques from a Crucifixion
Gold, cloisonné enamel, each: 4¼ × 1½ in.
The Metropolitan Museum of Art, New York, Gift of J. Pierpont Morgan, 1917.
17.190.713,714

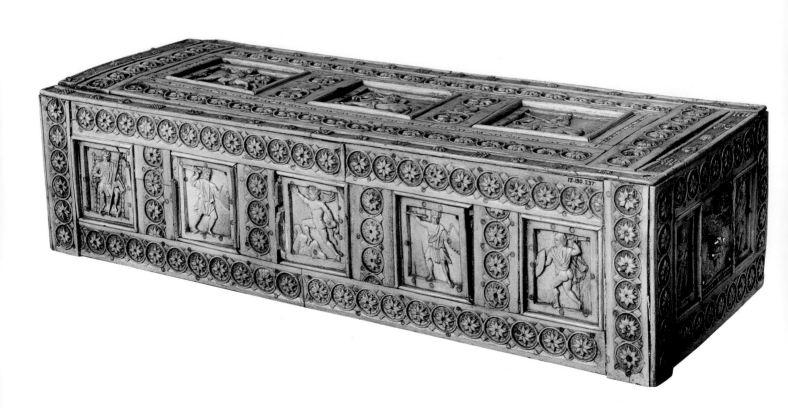

Frick, John G. Johnson, Henry Walters, Edward Harkness—whose private collecting had some of the feverish enthusiasm of his own. At openings, Morgan would receive like royalty, standing on a near-acre of Oriental rug in the Great Hall. On one occasion he caught sight of a woman in the line who held a baby in her arms and ordered that a $1,000 life membership be taken out for the child (who, ironically, developed cataracts of both eyes by the age of five). But he also devoted much time to museum meetings. No acquisition, no change of architectural detail, no appointment was made without consulting him. He was determined to make the Metropolitan Museum the finest institution of its sort in the world.

Casket with Various Mythological Figures
Byzantine, 10th c.
Ivory, 17¼ × 4 × 6⅞ in.
The Metropolitan Museum of Art, New York, Gift of J. Pierpont Morgan, 1917. 17.190.237

Virgin and Child
Byzantine, 11th c.
Ivory
The Metropolitan Museum of Art, New York, Gift of J. Pierpont Morgan, 1917. 17.190.103

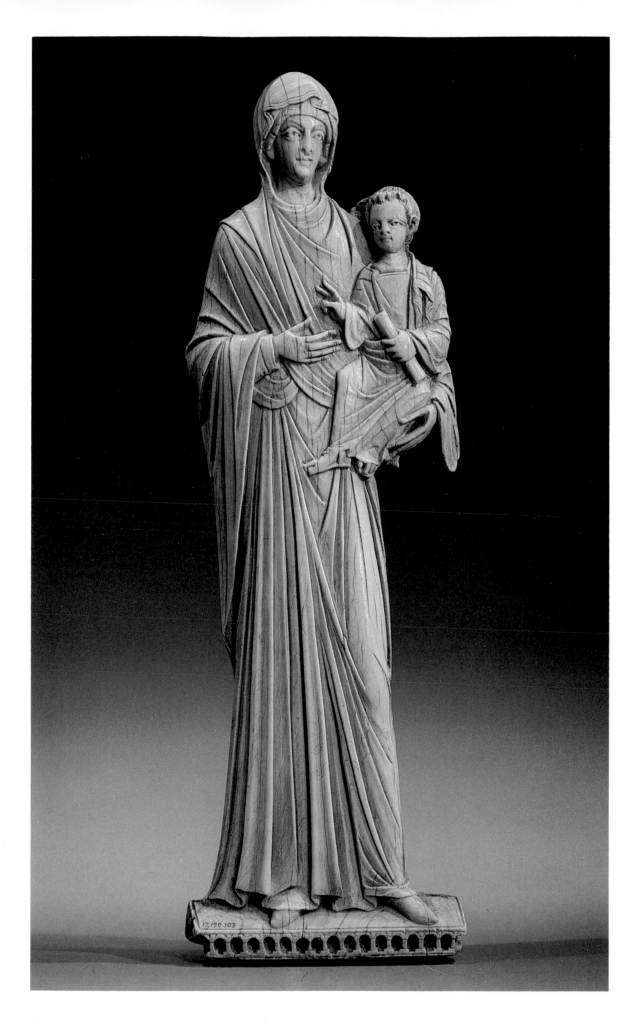

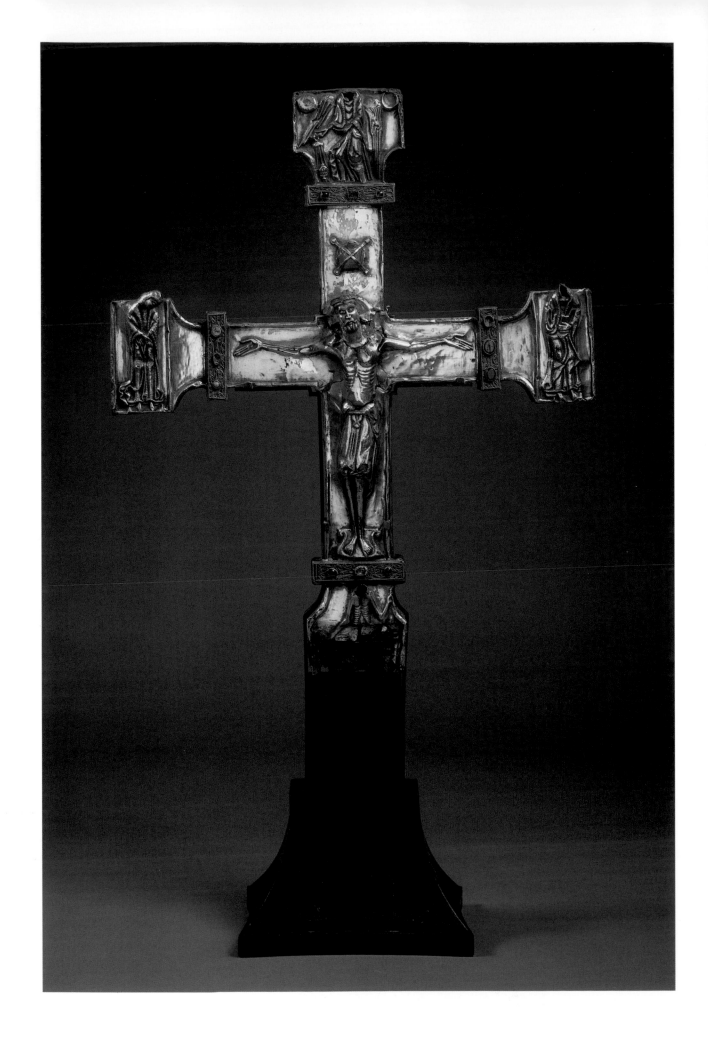

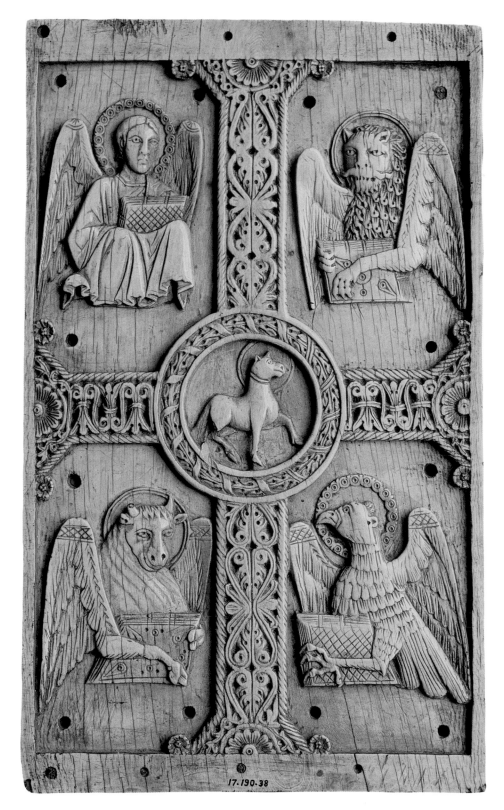

Processional Cross
From the Church of San Salvador de
Fuentes, near Villaviciosa, Asturias
North Spanish, first half 12th c.
Silver repoussé and parcel gilt, filigree,
gems, crystal on wood, H. 23¼ in.
The Metropolitan Museum of Art, New
York, Gift of J. Pierpont Morgan, 1917.
17.190.1406

*Agnus Dei and Symbols of the
Evangelists*
Plaque from a book cover
German or north Italian, prob. 9th c.
Ivory
The Metropolitan Museum of Art, New
York, Gift of J. Pierpont Morgan, 1917.
17.190.38

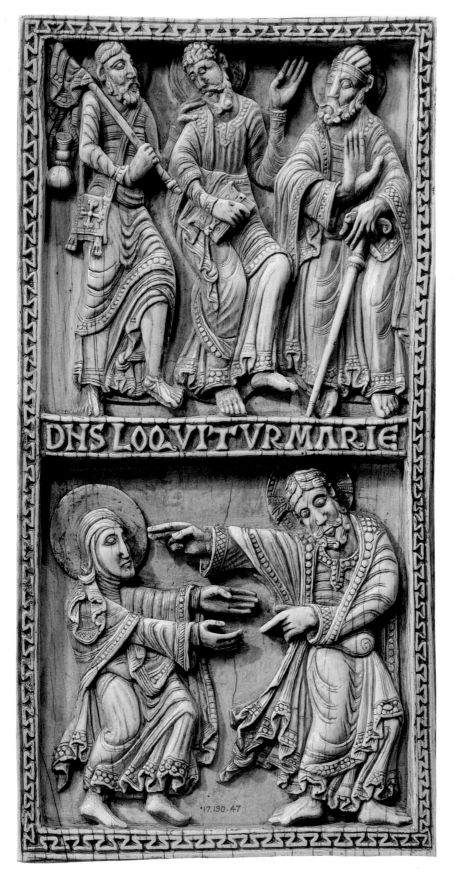

DHS LOQVITVRMARIE

The Journey to Emmaus, Noli Me Tangere
Leaf from a diptych
North Spanish, prob. Leon, late 11th c.
Ivory
The Metropolitan Museum of Art, New York, Gift of J. Pierpont Morgan, 1917. 17.190.47

Enthroned Virgin (with Christ Child missing)
North European, prob. Scandinavia, 12th c.
Wood with traces of original polychromy, H. 34 in.
The Metropolitan Museum of Art, New York, Gift of J. Pierpont Morgan, 1917. 17.190.716

Virgin and Child
French, prob. Paris, ca. 1270–1280
Oak with modern repaint, H. 15⅞ in.
The Metropolitan Museum of Art, New York, Gift of J. Pierpont Morgan, 1917. 17.190.725

Chasse or Reliquary with Crucifixion, Christ in Majesty, and Symbols of the Evangelists and Apostles
French, Limoges, ca. 1180
Champlevé enamel on copper gilt with vermicular pattern
The Metropolitan Museum of Art, New York, Gift of J. Pierpont Morgan, 1917. 17.190.514

36

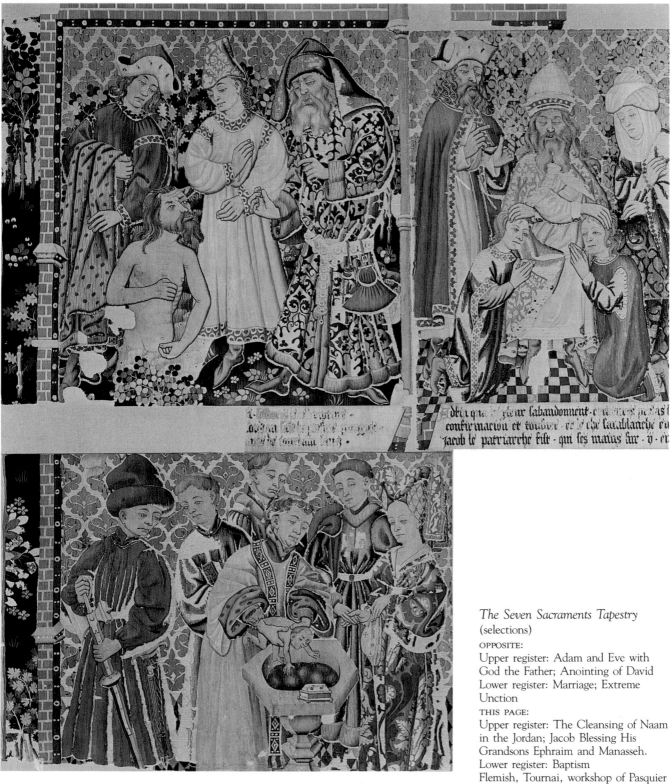

The Seven Sacraments Tapestry
(selections)

OPPOSITE:
Upper register: Adam and Eve with
God the Father; Anointing of David
Lower register: Marriage; Extreme
Unction

THIS PAGE:
Upper register: The Cleansing of Naam
in the Jordan; Jacob Blessing His
Grandsons Ephraim and Manasseh.
Lower register: Baptism
Flemish, Tournai, workshop of Pasquier
Grenier; third quarter 15th c.
Wool and silk
The Metropolitan Museum of Art, New
York, Gift of J. Pierpont Morgan, 1907.
07.57.1-5

Apostles in Prayer: Pentecost
Flemish, ca. 1400–1410
Oak
The Metropolitan Museum of Art, New
York, Gift of J. Pierpont Morgan, 1916.
16.32.214

St. Christopher and the Christ Child
French, Toulouse, ca. 1400
Silver parcel gilt, 23⅝ × 11¾ in.
The Metropolitan Museum of Art, New
York, Gift of J. Pierpont Morgan, 1917.
17.190.361

The Virgin Mourning
French, Gothic School of Touraine,
ca. 1450–1475
Walnut, H. 42¾ in.
The Metropolitan Museum of Art, New
York, Gift of J. Pierpont Morgan, 1917.
17.190.386

38

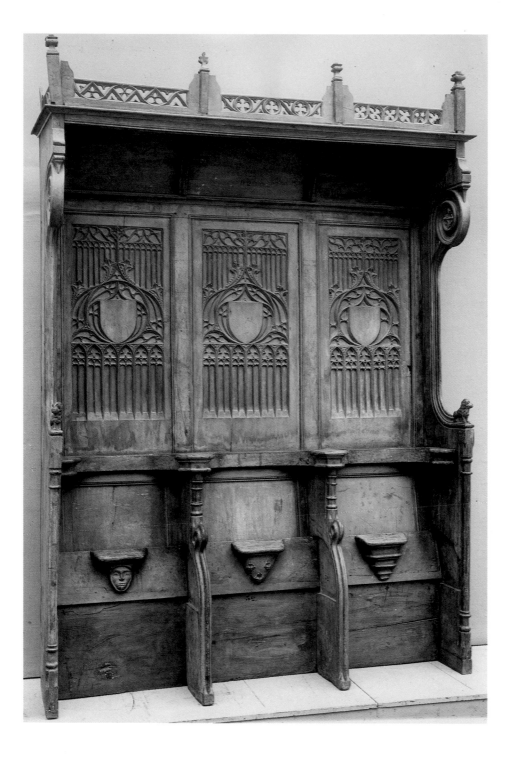

Triple Choir Stall
French, 15th c.
Walnut
The Metropolitan Museum of Art, New York, Gift of J. Pierpont Morgan, 1916. 16.32.23

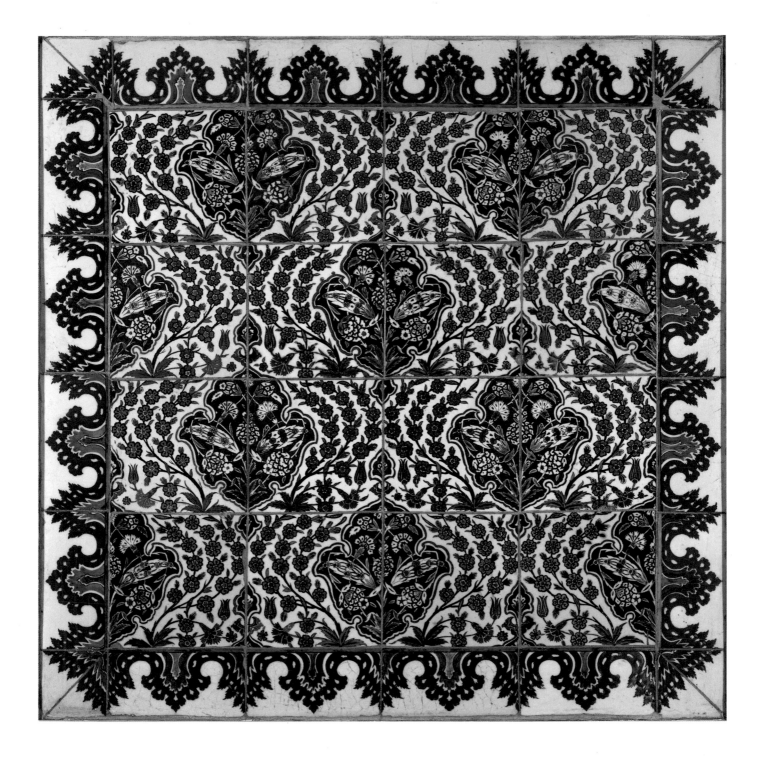

Panel of Wall Tiles
Turkish, Isnik, second half 16th c.
Faience, painted and glazed, 47 × 48 in.
The Metropolitan Museum of Art, New
York, Gift of J. Pierpont Morgan, 1917.
17.190.2083

41

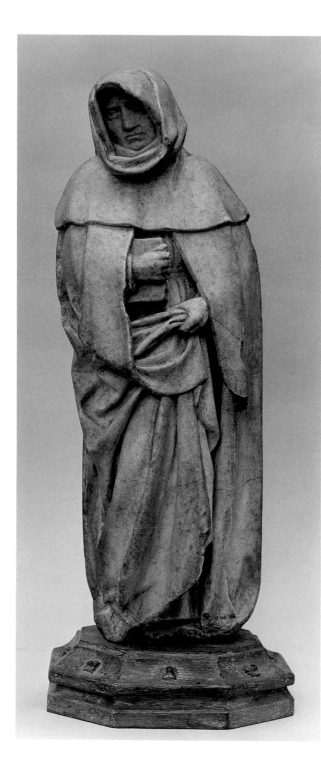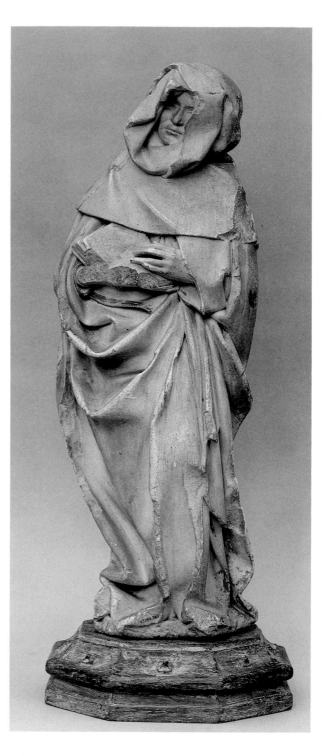

Mourners
Alabaster figures from the Tomb of the
Duc de Berri at Bourges, France
Etienne Bobillet and Paul Mosselman
French, Burgundy, ca. 1453
The Metropolitan Museum of Art, New
York, Gift of J. Pierpont Morgan, 1917.
17.190.386,389

42

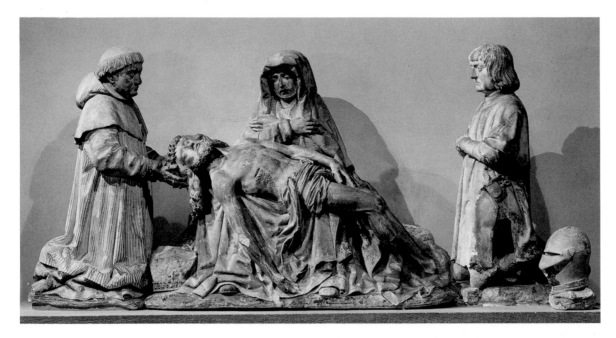

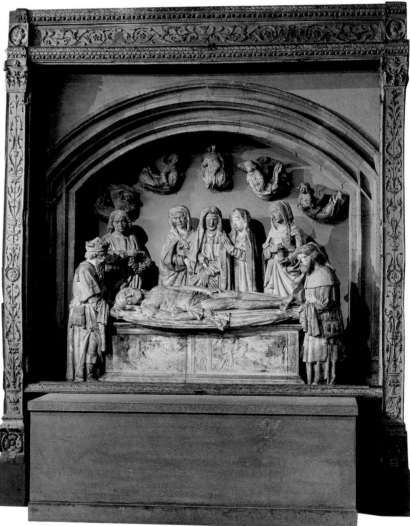

Pietà with Donors and *Entombment with Donors*
From the chapel of the Château de Biron, Perigord
French, Bourbonnais, ca. 1515
The Metropolitan Museum of Art, New York, Gift of J. Pierpont Morgan, 1916. 16.31.1,2

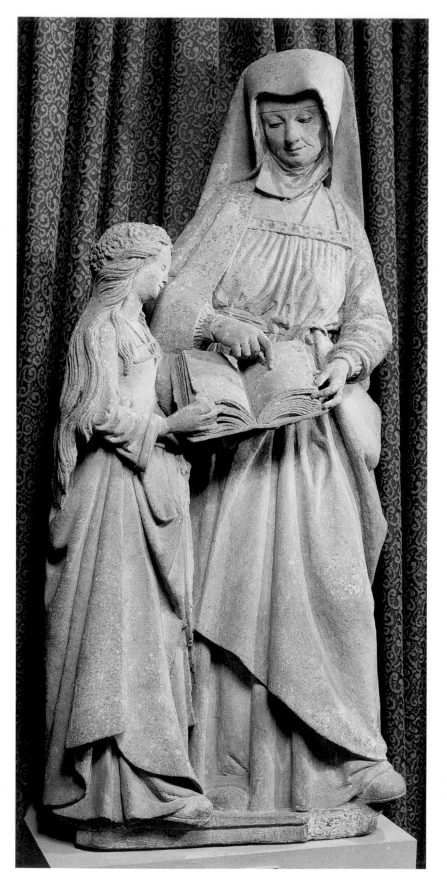

The Education of the Virgin: St. Anne and the Virgin as a Child
French, School of Troyes, ca. 1510–1520
Sandstone, H. 57¾ in.
The Metropolitan Museum of Art, New York, Gift of J. Pierpont Morgan, 1916. 16.32.31

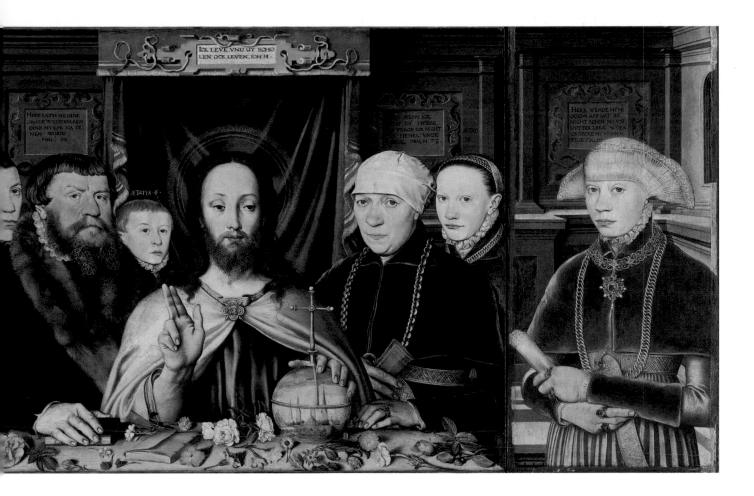

*Christ Blessing, Surrounded by a
Donor and His Family*
Attrib. Ludger Tom Ring, the Younger
German, 1522–1584
Tempera and oil on wood; central
panel: 31⅜ × 37⅝ in.; each wing:
23 × 14⅝ in.
The Metropolitan Museum of Art, New
York, Gift of J. Pierpont Morgan, 1917.
17.190.13–15

Fleet of Aeneas Arriving in Italy
Master of the Aeneid
French, Limoges, ca. 1525–1530
Plaque of painted enamel after
woodcuts in Johann Gruniger's *Aeneid*,
Book III, f. 201
The Metropolitan Museum of Art, New
York, Gift of J. Pierpont Morgan, 1925.
25.40.2

*Chalice with Old and New Testament
Figures and Scenes from the Passion*
Spanish, late 15th c.
Silver gilt and translucent enamel
The Metropolitan Museum of Art, New
York, Gift of J. Pierpont Morgan, 1917.
17.190.265

46

Helenus and Andromache Exchanging Gifts
Master of the Aeneid
French, Limoges, ca. 1525–1530
Plaque of painted enamel after
woodcuts in Johann Gruniger's *Aeneid*,
Book III, f. 201
The Metropolitan Museum of Art, New
York, Gift of J. Pierpont Morgan, 1925.
25.40.1

47

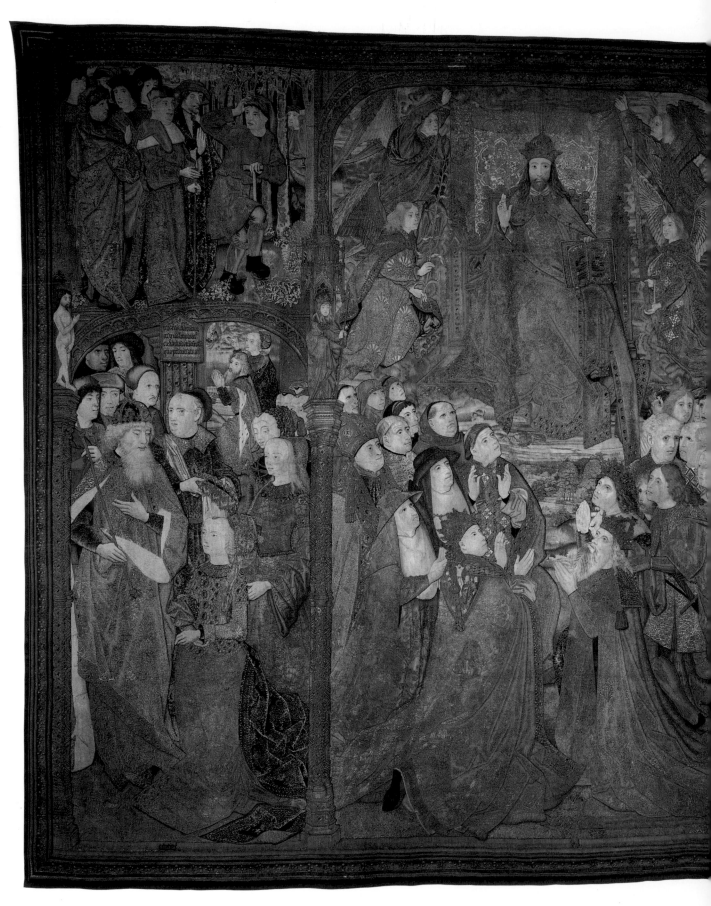

48

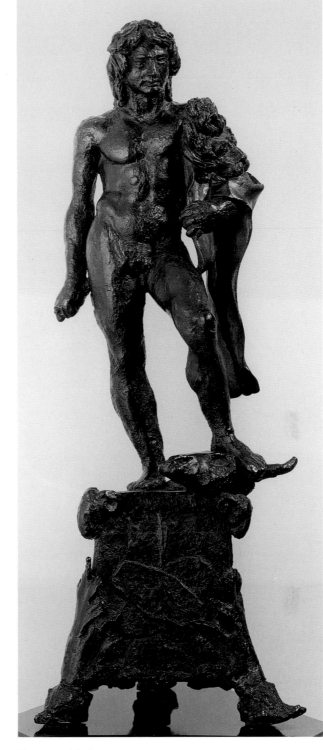

*The Mazarin Tapestry with the
Triumph of Christ*
French, ca. 1500
Wool, silk, gold, and silver,
133 × 163 in.
The National Gallery of Art,
Washington, D.C. Widener Collection.
1942.9.446

Hercules
Antonio Pollaiuolo
Italian, Florence, 1426/32–1498
Bronze
The Frick Collection, New York

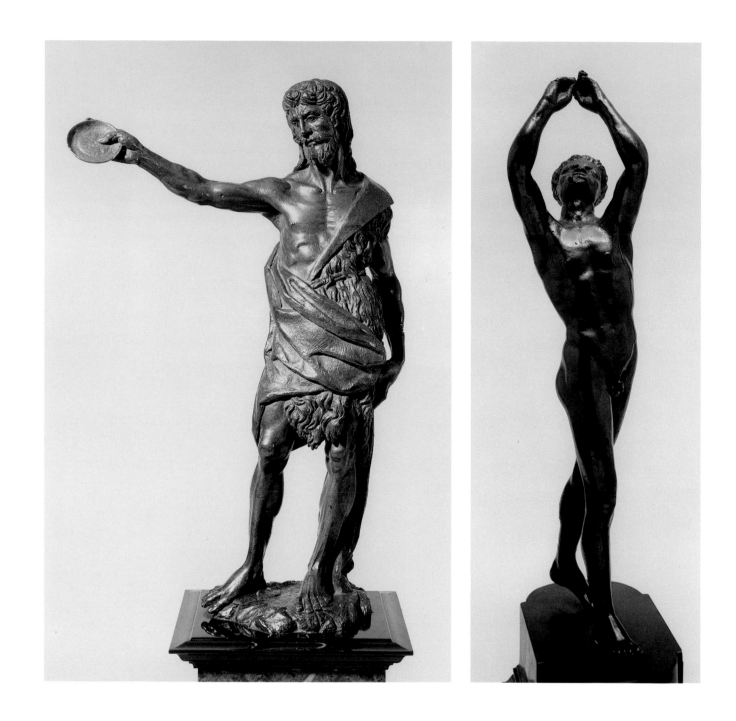

Saint John Baptizing
Francesco de Sangallo
Italian, Florence, 1494–1576
Bronze
The Frick Collection, New York

Faun Playing the Flute
Vittore di Antonio Gambello (called
Camelio)
Italian, Venice, 1455/60–1537
Bronze
The Frick Collection, New York

50

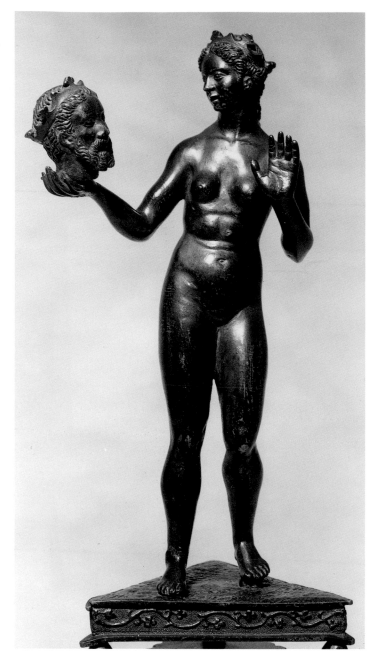

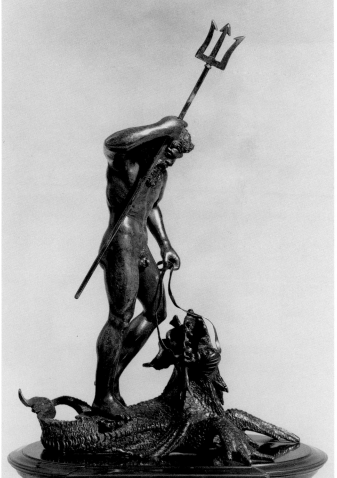

Queen Tomyris with the Head of Cyrus
Severo da Ravenna
Italian, Padua, late 15th–early 16th c.
Bronze
The Frick Collection, New York

Neptune on a Sea Monster
Severo da Ravenna
Italian, Padua, late 15th–early 16th c.
Bronze
The Frick Collection, New York

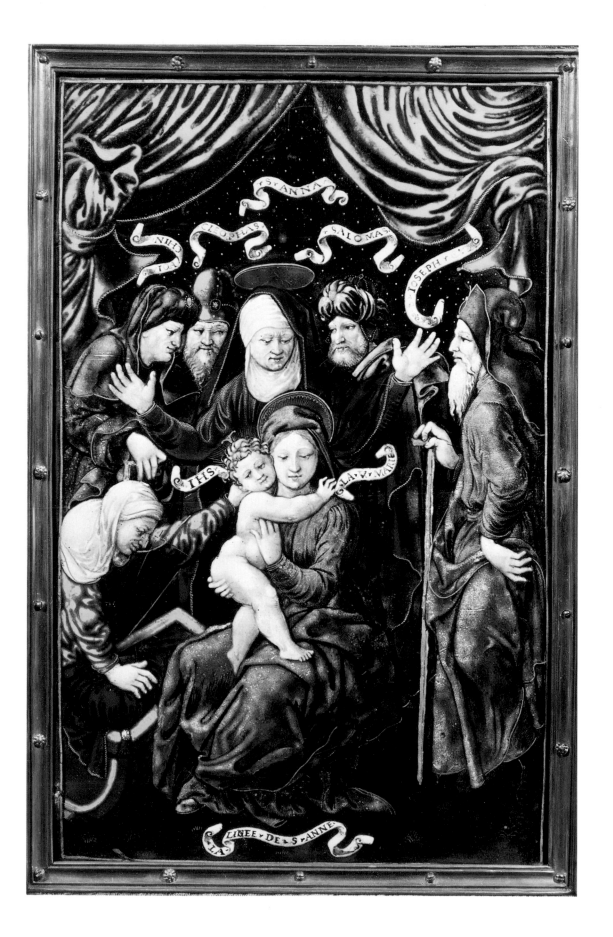

52

Morgan as
a Collector

HE HAD THE WISDOM TO RELY HEAVILY ON THE advice of experts, to name but a few: Sir Hercules Read of the British Museum, Wilhelme von Bode of the Kaiser Friedrich Museum, William M. Laffan, editor of the New York *Sun* and an expert in Chinese porcelains, the comte de Chavagnac and J.H. Fitzhenry for French porcelains, Dr. G.C. Williamson for miniatures, and of course, the whole staff of the Metropolitan Museum. And in later years, particularly in the field of books, he counted on the gimlet eye of his extraordinary librarian and assistant, the remarkable Belle da Costa Greene.

No matter what the experts said, however, he made a point of never purchasing an object he or Belle hadn't seen. There were those who accused him of not looking at the object when it was before him, but that may have been because he was looking into the eye of the seller. This was particularly so when he asked, as he frequently did, what the seller had paid for it. Of course, the man could lie or decline to answer, but in the event of discovery—and Morgan had formidable resources—he would have ruined himself with the greatest of collectors. As George S. Hellman, who sold him many books, has said in *Lanes of Memory:* "The abruptness of Mr. Morgan's query and the piercing quality of his dark eyes did not tempt one to circumvention. It was," he added, "a great mistake to think that he was a man of whom dealers could easily take advantage."

He could on occasion make up his mind impulsively, even sentimentally, but he always knew just what he was doing. He made the decision to buy the Americana collection of S.H. Wakeman, a New York bibliophile, after Hellman had read aloud to him the first stanza of the manuscript of Longfellow's "The Children's Hour":

> Between the dark and the daylight,
> When the night is beginning to lower,

Lineage of St. Anne
Central panel of a triptych
Workshop of Jean II Pénicaud
French, 1531–1549
Enamel; 11¾ × 7½ in;
The Frick Collection, New York

53

Comes a pause in the day's occupations
That is known as the children's hour.

Morgan took the manuscript from Hellman, finished reading the poem to himself, hit the table with his fist, and exclaimed: "I'll take the collection!" It had been an all-or-nothing proposition.

Hellman also tells the story of Morgan's first encounter with Vermeer, a painter of whom he had not heard, which was not surprising in view of the artist's long obscurity and very recent fame. He listened carefully to the dealer's evaluation of the quality of the picture, reexamined it, and bought *A Lady Writing* (now in the National Gallery of Art) on the spot for one hundred thousand dollars.

But he was not apt to be so quick as these examples might lead one to believe. He often distressed dealers by keeping objects on approval for months at a time while asking visiting experts to his house for their opinion of them.

What made Morgan different from many American collectors and more like a Renaissance cardinal or a Lorenzo il Magnifico was that the beautiful things with which he surrounded himself were to him in total harmony with the daily task of financing business corporations. As Robert W. de Forest, a vice president of the Metropolitan, said: "To him it was not incongruous to assemble the forces which stayed the Panic of 1907 for that famous all-night session at his library in the company of a placid Madonna and a delicate statuette by Donatello."

But as there were no Lorenzos in Morgan's America, one had to look abroad for the nearest parallel to him. Francis Henry Taylor thought: "Only in England where the great commoner families of the landed gentry had always occupied a far more influential position than the *noblesse de la robe* was there any real insight into Pierpont Morgan's character and motives."

What was his grand objective, if he had one? According to Humphrey Ward, one of his cataloguers, "His object has been to possess at least one or two examples of all the great schools—while in the case of the English and French schools of the eighteenth century he has allowed his natural predilections to have free play."

But I think it was more than that. Linda Horvitz Roth, in her introduction to a book published by the Wadsworth Atheneum on the Morgan collection there, wrote: "His collecting

*Predella: Saint Nicholas of Tolentino
Reviving the Birds*
Benvenuto Tisi da Garofalo
Italian, Ferrara, ca. 1481–1559
Oil on canvas transferred from wood,
12⅞ × 26 in.
The Metropolitan Museum of Art, New
York, Gift of J. Pierpont Morgan, 1917.
17.190.23

appears to have been rooted in that same idealistic and patriotic vision of America that had guided his business life."

This seems to me to catch the right note. It may explain why he never bought American art. American art was already *here,* and his mission, as he conceived it, was to bring the glory of European art and ancient civilizations to his native land. In the words of Aline B. Saarinen: "He meant to gather for America an undreamed-of collection of art so great and so complete that a trip to Europe would be superfluous." Indeed, so intense was his concentration on what the old world could do for the new that when he came to build his beautiful library on Thirty-sixth Street he commissioned Charles McKim to design an Italian palazzo and Henry Siddons Mowbray to paint murals that might have been taken from Italian Renaissance walls. There is not a Yankee note in the whole structure.

But it is important to remember how barren of culture was the America of Morgan's youth. Henry James, who was only four years younger, had fled to Europe in search of an artistically richer life, expressing his famous lament in his life of Hawthorne that the latter's America (by which he very much meant his own)

had no palaces, no castles, no thatched cottages or ivied ruins, no cathedrals, no literature, no novels, no museums, and no pictures! This complaint of James has been much mocked and resented, but there was some truth in it, and it was precisely these romantic lacks that Morgan intended to supply.

It is curious that Henry James, who was so close to Morgan in age and who had so many American and English friends in common with him, including Jonathan Sturges, Mimi's cousin, should not have mentioned Morgan in any of the many volumes of his notebooks or letters, but he certainly knew him and he certainly knew about the great transmission of Morgan's English collections from London to New York in 1912. After all, he had written *The Outcry* to protest Britain's loss of its great art treasures. But I suspect that he made a distinction between Morgan and other collectors in that he appreciated Morgan's grand scheme for enriching his native land. It may well have been the Morgan collection that inspired his vision of Adam Verver in *The Golden Bowl*. Verver has made his great fortune while still young, and it is with a fine ecstasy that he comes to realize that another and greater career awaits him in the form of putting together a peerless collection of European art to be housed in his hometown and to redeem it from all its bareness and ugliness. Here is how the concept comes to Verver, after reading Keats's sonnet about Cortez (in fact Balboa) faced with the broad Pacific:

> His "peak in Darien" was the sudden hour that had transformed his life, the hour of his perceiving with a mute inward gasp akin to the low moan of apprehensive passion, that a world was left him to conquer and that he might conquer it if he tried. It had been a turning of the page of the book of life—as if a leaf long inert had moved at a touch and, eagerly reversed, had made such a stir of the air as sent up into his face the very breath of the Golden Isles. To rifle the Golden Isles had, on the spot, become the business of his future, and with the sweetness of it—what was most wondrous of all—still more even in the thought than in the act. The thought was that of the affinity of Genius, or at least of Taste, with something in himself— with the dormant intelligence of which he had thus almost violently become aware and that affected him as changing by a mere revolution of the screw his whole intellectual

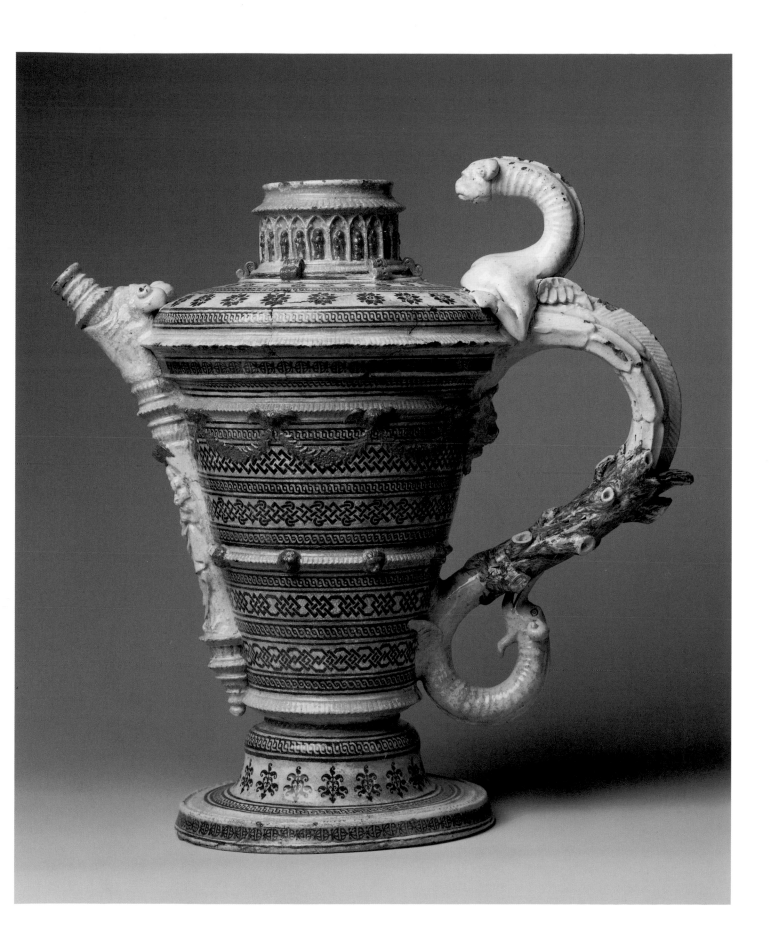

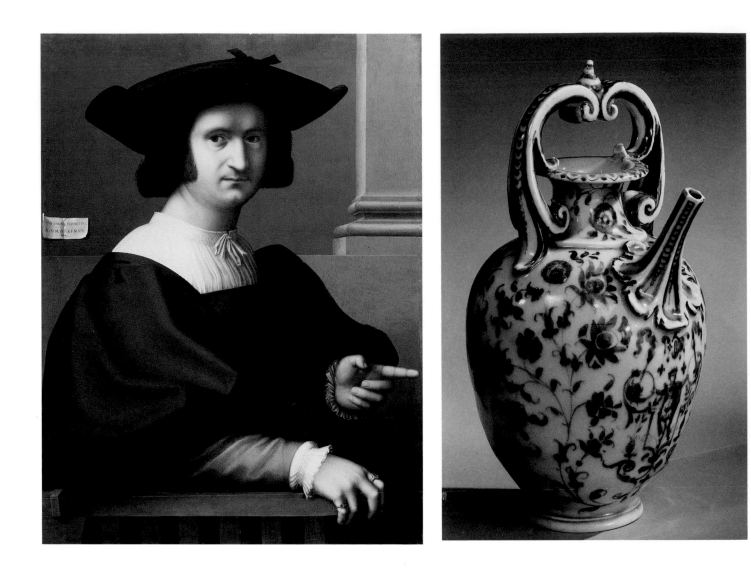

plane. He was equal, somehow, with the great seers, the invokers and encouragers of beauty—and he didn't after all perhaps dangle so far below the great producers and creators.

And there are certainly reminders of Morgan in the dialogue between Adam Verver's daughter and sole heir and the impoverished but beautiful Italian prince who has been chosen to be her consort. Maggie, too much in love to know how close she is to the truth, plays with the idea that her fiancé is the prize jewel of her father's collection.

"There are things," she had gone on, "that father puts away—the bigger and more cumbrous of course, which he stores, has already stored in masses, here and in Paris, in

Portrait of a Man
Tommaso di Stefano Lunetti (called Tommaso Fiorentino)
Italian, Florence, ca. 1495–1564
Tempera on wood, 32¼ × 23⅞ in.
The Metropolitan Museum of Art, New York, Gift of J. Pierpont Morgan, 1917. 17.190.8

Ewer
Italian, Florence, 16th c.
Soft-paste porcelain, H. 8 in.
The Metropolitan Museum of Art, New York, Gift of J. Pierpont Morgan, 1917. 17.190.20

Italy, in Spain, in warehouses, vaults, banks, safes, wonderful secret places. We've been like a pair of pirates—positively stage pirates, the sort who wink at each other and say 'Ha-ha!' when they come to where their treasure is buried. Ours is buried pretty well everywhere—except what we like to see, what we travel with and have about us. These, the smaller pieces, are the things we take out and arrange as we can, to make the hotels we stay at and the houses we hire a little less ugly. Of course it's a danger, and we have to keep watch. But father loves a fine piece, loves, as he says, the good of it, and it's for the company of some of his things that he's willing to run his risks. And we've had extraordinary luck; we've never lost anything yet. And the finest objects are often the smallest. Values, in lots of cases, you must know, have nothing to do with size. But there's nothing, however tiny, that we've missed."

"I like the class," he had laughed at this, "in which you place me! I shall be one of the little pieces that you unpack at the hotels, or at the worst in the hired houses, like this wonderful one, and put out with the family photographs and the new magazines. But it's something not to be so big that I have to be buried."

"Oh," she had returned, "you shall not be buried, my dear, till you're dead. Unless indeed you call it burial to go to American City."

One of the difficulties in assessing Morgan as a collector is that he bought almost everything. A man who buys another man's collection may be seeking a few jewels in a gallery of the second rate; it is hard to tell. And Morgan bought any number of collections. It is not my purpose here to make an inventory of these, but the following partial list should give the reader an idea of the quantity:

The "Library of Leather and Literature" of James Toovey with many tooled leather bindings. Three fifths of the George B. de Forest collection of French literature. Most of the library of Theodore Irwin, including the "Golden Gospels" of the duke of Hamilton (written in English for Archbishop Wilfred of York in the seventh century and given by Henry VIII to Pope Leo X when the latter named him Defender of the Faith), the *Apocalypse* of the duc de Berri, and twenty-seven Rembrandt etchings. The collection of Richard Bennett of Manchester, England, includ-

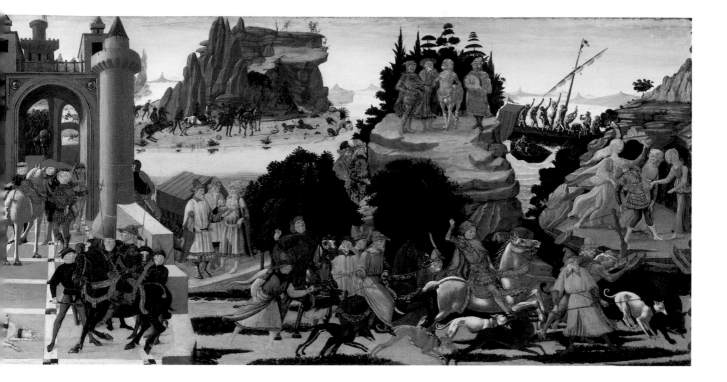

Scenes from the Story of the Argonauts
Workshop of Biagio di Antonio
Italian, Florence, 1476–1504
Cassone panel, tempera on wood, gilt
ornaments, each: 24⅛ × 60⅜ in.
The Metropolitan Museum of Art, New
York, Gift of J. Pierpont Morgan, 1909.
09.136.1,2

ing much of the library of William Morris and thirty-two Cax-tons. The Wakeman collection of American manuscripts. The Fairfax Murray collection of drawings. The James A. Garland collection of ancient glass and oriental porcelains. The Gaston LeBreton collection of French faience. The Marfels collection of watches. The Gutmann collection of antique plates and bronzes. I pause for breath.

The collection of one thousand coins from ancient Greece and her colonies of John Ward, described by an admirer as "one of those cultivated, widely-travelled Englishmen whose whole-hearted devotion of their leisure at home and abroad to some favorable pursuit often produces a valuable addition to the sum of the world's knowledge." The Marsden J. Perry collection of Chinese porcelains. The George Hoentschel collection of deco-rative arts housed in a two-story private gallery in Paris. Hoentschel was an architect who specialized in the restoration and reconstruction of Gothic and eighteenth-century interiors. The collection included all kinds of woodwork: garlands, fes-toons, brackets, balustrades, panels, overdoors, cabinets, chairs, tables, frames, pedestals, doors, and ormolu decorations.

The list goes on and on.

It is difficult to establish any chronology in Morgan's collect-ing, except in the roughest way. It seems that in the decade of the 1890s he concentrated on European objects from the end of the Roman Empire to the Renaissance. We might make the follow-ing divisions:

Gallo-Roman, Germanic, and Merovingian. This would be art of the period from the fall of the Roman Empire to the end of the Carolingian era, the fourth to the tenth century A.D., a time that marked a connecting link between the classical and the medieval. The collection here is largely of articles of personal use and adornment recovered from tombs in France and Germany: brooches, fibulae, belt buckles, studs, purses, rings, armlets, earrings, hairpins, combs, pendants, necklaces, horse-trappings.

Byzantine. This is the period from the fourth to the eleventh centuries (with the lacuna of the 116 years of the iconoclast emperors ending in 822). The artifacts of this era are principally items of ecclesiastical usage made in precious materials represent-ing prime work of goldsmiths, enamelers, and ivory carvers. The Byzantines specialized in cloisonné enamels; studs and bands of

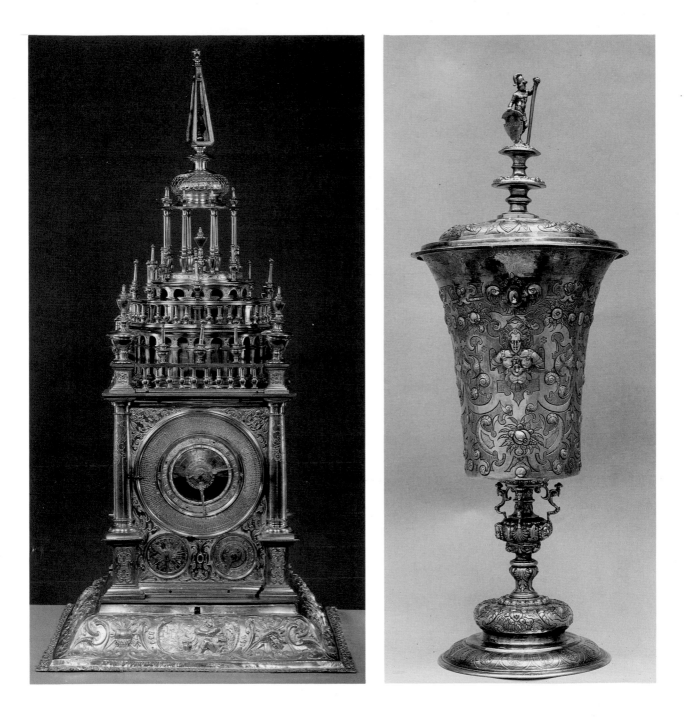

dance programs that he bought and in the craft of the wood-worker for house interiors.

And at all times he was buying clocks, porcelains, paintings, books and manuscripts, drawings, and sculptures of many countries and eras.

Toward the end of his life Morgan seemed to be turning more to the ancient past, particularly in Egypt, and to the Orient.

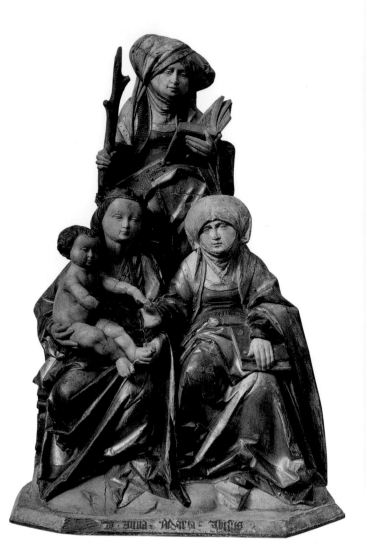

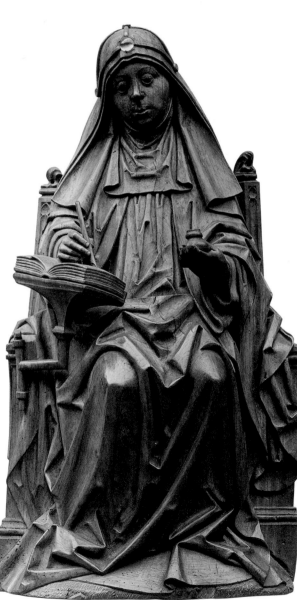

St. Emerentia with Virgin and Child and St. Anne
German, Augsburg School (Urban Master of Hildesheim), ca. 1515–1530
Wall statuette, polychrome and gilt, H. 33 in.
The Metropolitan Museum of Art, New York, Gift of J. Pierpont Morgan, 1916. 16.32.208

St. Bridget of Sweden
From the Cloister of Soeterbeeck German, Lower Rhenish School (Calcar), ca. 1500
Walnut, H. 34 in.
The Metropolitan Museum of Art, New York, Gift of J. Pierpont Morgan, 1916. 16.32.197

The Morgan Collections Come to America

IN 1909 THE UNITED STATES FINALLY ABOLISHED ITS 20 percent import duty on works of art created more than a century before, and it became economically feasible for Morgan to transfer his vast collections in England to his native country. His favorite pieces had been kept in his big double town mansion at Prince's Gate and at Dover House just outside of London, but the bulk of his accumulations were on loan to the Victoria and Albert Museum. In 1912 the great move across the Atlantic was accomplished.

The departure of such a trove of art from English soil aroused considerable indignation, and the letter column of the London *Times* was filled with a sputtering correspondence. The fact that only a small fraction of the works of art were from British collections or by British artists seems to have made little difference. "National treasures" means nationally located treasures to the greater public, and what most angered the Paris crowds in the demands of the occupying allies after Waterloo was the forced return to Venice of the four horses from San Marco, which Napoleon had seized as the spoils of war! In the case of the Morgan shipment, however, the matter was aggravated by the fact that so many of his finest things had been on what people had begun to consider a permanent loan at the Victoria and Albert Museum.

The loss of the Morgan collection, at least to British hopes, also marked the climax of a period when the public had become increasingly and indignantly aware of the selling, largely by noble families, to foreigners, largely American, of their ancestral treasures. If Henry James had had Morgan in mind when he drew his admiring portrait of Adam Verver in *The Golden Bowl* in 1904, he had altered his valuation by 1909 when he wrote *The Outcry* to dramatize the problem of the loss of a great heritage.

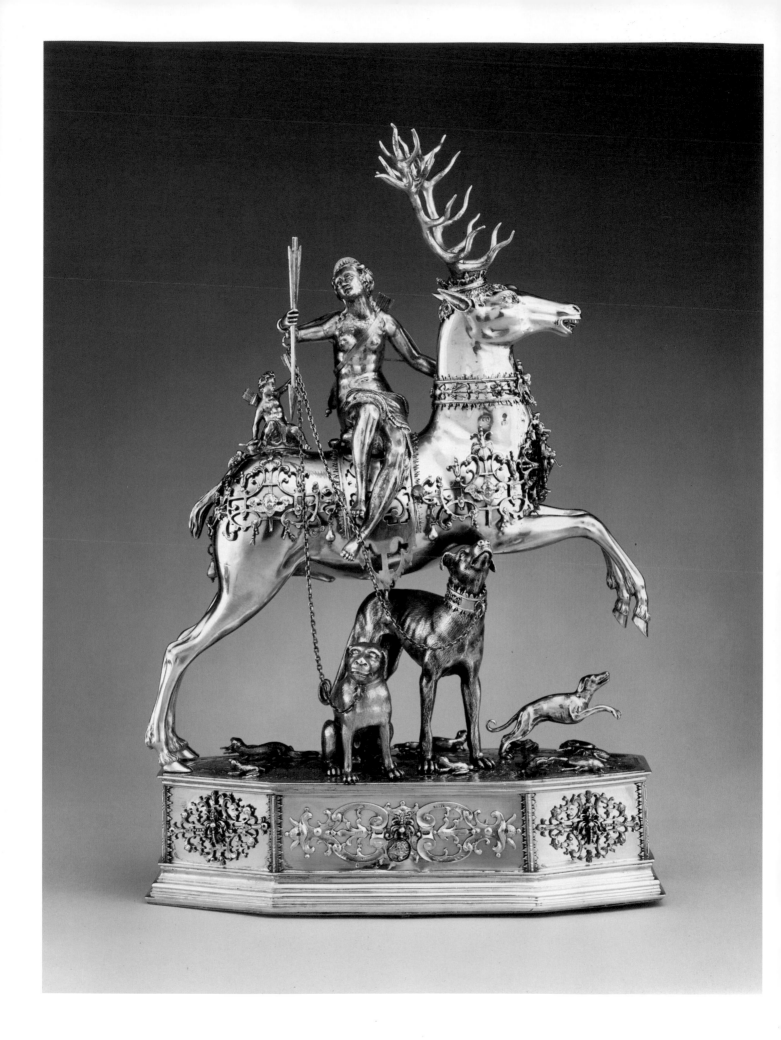

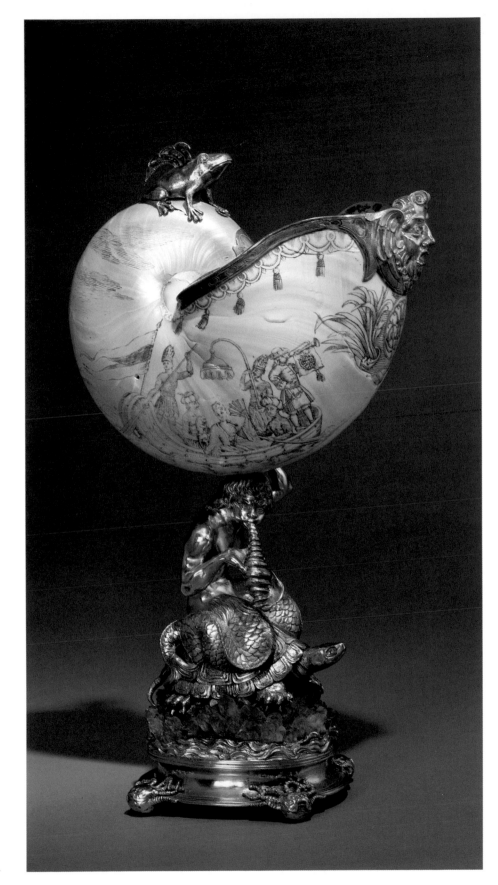

Automaton: Diana and the Stag,
ca. 1620
Joachim Friess
German, Augsburg, ca. 1579–1620
Case of silver, partly gilded and
enameled, and set with jewels, with
movement of iron and wood. (The
stag's head comes off to reveal a
drinking vessel; the mechanism propels
the stag down the table to serve the
drinkers.)
The Metropolitan Museum of Art, New
York, Gift of J. Pierpont Morgan, 1917.
17.190.746

Nautilus Goblet, ca. 1620
Georg Mund
German, Dresden
Shell, silver gilt, amethyst crystals, H.
12^{13}⁄₁₆ in.
Wadsworth Atheneum, Hartford, J.
Pierpont Morgan Collection. 1917.269

70

Now he had come to see his compatriots as a "conquering horde" armed with checkbooks, "dim, vast, portentous—in their millions—like gathering waves—the barbarians of the Roman Empire." And the villain of his play, Breckenridge Bender, a hardheaded and predatory Yankee collector, seems to have some of the features of Morgan himself.

In America the shipment also aroused lively public speculation as to its ultimate disposition. Morgan had been the dominant figure on the Metropolitan board for many years; he had either loaned or given much of the best that the institution had to display. Robert W. de Forest, a vice president, felt impelled to put this announcement in the museum *Bulletin* of February 1912: "The widespread publicity that has been given by the press to Mr. Morgan's transfer of his collections from the Victoria and Albert Museum in London to New York, and the inferences drawn of his intentions towards our Metropolitan Museum, call for some statement from his fellow trustees in his absence to distinguish fact from fiction and to prevent public misunderstanding."

De Forest went on to say: "As to whether he expects to give or lend we are ignorant. Possibly he may not have made up his mind himself. . . . What we do know is that even if the galleries which can now be used to show some of his treasures can be permanently devoted to this purpose, the space is utterly inadequate to exhibit all of them, and nothing short of another extension to the museum will suffice to do so."

He ended with a clear message to City Hall: "That New York has the opportunity is clear."

The city owned (as it still does) the building housing the Metropolitan's art and was responsible for its maintenance and improvement, but it was only to be expected that the mayor and Board of Estimate should ask for a commitment from Morgan before embarking on such an expense. Edward Robinson, the museum's director, was entrusted with the delicate task of sounding out the great man on his arrival from Europe at the end of that month.

His mission was not successful. Morgan told him flatly that he had no intention of leaving his art to the Metropolitan, and the city was to be so informed. The collections would constitute too large a portion of his estate to be subject to a single bequest.

The Beheading of John the Baptist
German, Rhenish, mid-16th c.
Hone stone, partially gilded, 11½ in. square
The Metropolitan Museum of Art, New York, Gift of J. Pierpont Morgan, 1917. 17.190.742

Death of the Virgin
German, Lower Rhenish School (Calcar), early 16th c.
Walnut high relief
The Metropolitan Museum of Art, New York, Gift of J. Pierpont Morgan, 1916. 16.32.210

71

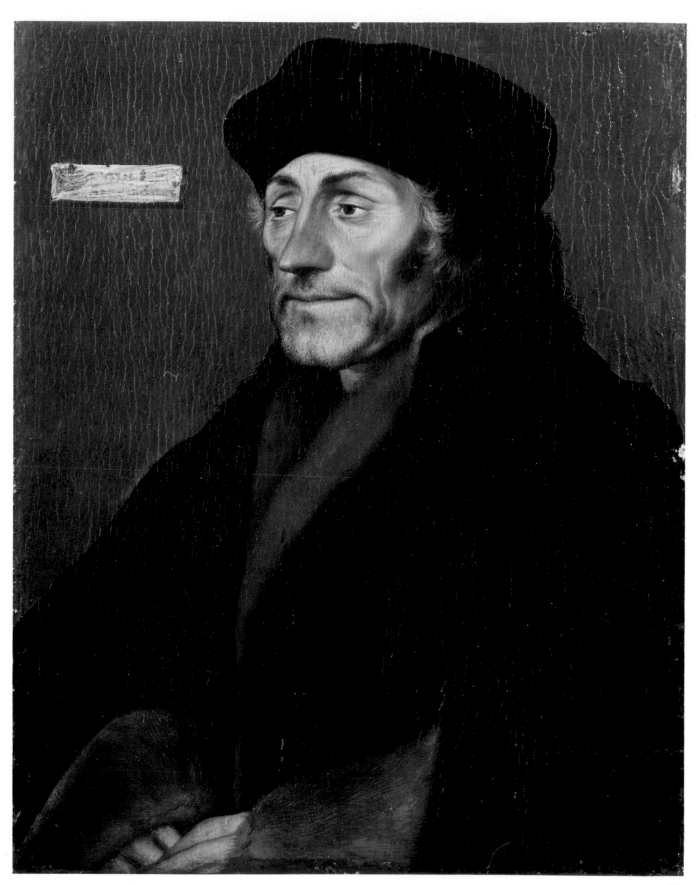

72

Desiderius Erasmus
Hans Holbein, the Younger
German, 1497?–1543
Oil on wood, 7⅜ × 5¾ in.
The Metropolitan Museum of Art, New
York, Robert Lehman Collection.
1975.1.138

*Tankard with the Queen of Sheba
before Solomon*, 1692?
Prob. Christopher Maucher
North German, Danzig, 1642–after
1705
Ivory, silver gilt, H. 8½ in.
Wadsworth Atheneum, Hartford, J.
Pierpont Morgan Collection, 1917.308

The Fall of Man
South German-Austrian, 2nd third
17th c.
Ivory, H. 12¹¹/₁₆ in.
Wadsworth Atheneum, Hartford, J.
Pierpont Morgan Collection. 1917.303

*Ship with Silver Gilt Hull and Oval
Base Embossed with Waves and
Dolphins*
Elias zur Linden
German, Nuremberg, early 17th c.
The Metropolitan Museum of Art, New
York, Gift of J. Pierpont Morgan, 1917.
17.190.319

Standing Cup with Cover
German, prob. Freiburg im Breisgau,
ca. 1630–1640
Rock crystal, with enameled gold
mounts set with jewels, H. 9 in.;
W. 4½ in.; D. 4½ in.
The Metropolitan Museum of Art, New
York, Gift of J. Pierpont Morgan, 1917.
17.190.539 ab

And indeed when Morgan died the following year, his will
bequeathed his art, which was valued at sixty millions, almost
half of his total assets, to his son, J.P., Jr.

It was known, however, that Morgan's son was planning to
carry out his father's expressed wish that the collections should
be distributed to museums, and as the Metropolitan was the most
likely to be preferred, the city was induced to go ahead with the
proposed extensions. On May 27, 1913, less than two months
after his father's death, J.P. Morgan, Jr. wrote to the museum's
board:

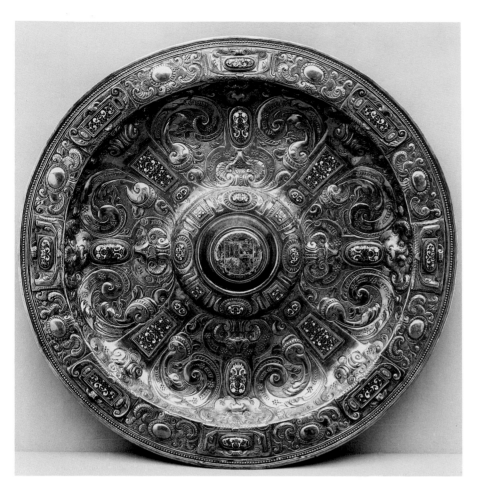

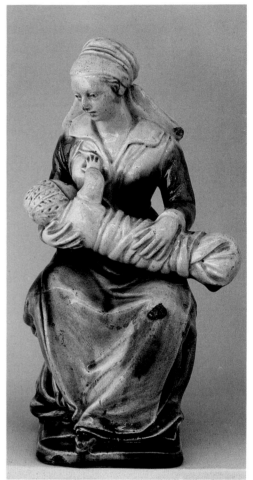

*Basin with the Arms of Castille,
Leon, and France*
Spanish, early 17th c.
Silver gilt and cloisonné enamel,
D. 26 in.
The Metropolitan Museum of Art, New
York, Gift of J. Pierpont Morgan, 1917.
17.190.570

Nurse with Child, ca. 1620
Claude Barthelemy
French, Avignon
Glazed earthenware
The Metropolitan Museum of Art, New
York, Gift of J. Pierpont Morgan, 1917.
17.190.2057

It is my desire that the objects of art left by my father
should be exhibited for the benefit of the public as soon as
may be. I know that it was in my father's mind to make a
loan exhibition of them in the new south wing which is to
be built, for which I understand that an appropriation has
been assured by the Board of Estimate. . . . If it can be
done, therefore, I should be glad to have the things shown
at a loan exhibition to be opened some time early in the
year 1914.

And so it came about that for the first and only time the
Morgan collections were exhibited as a whole.

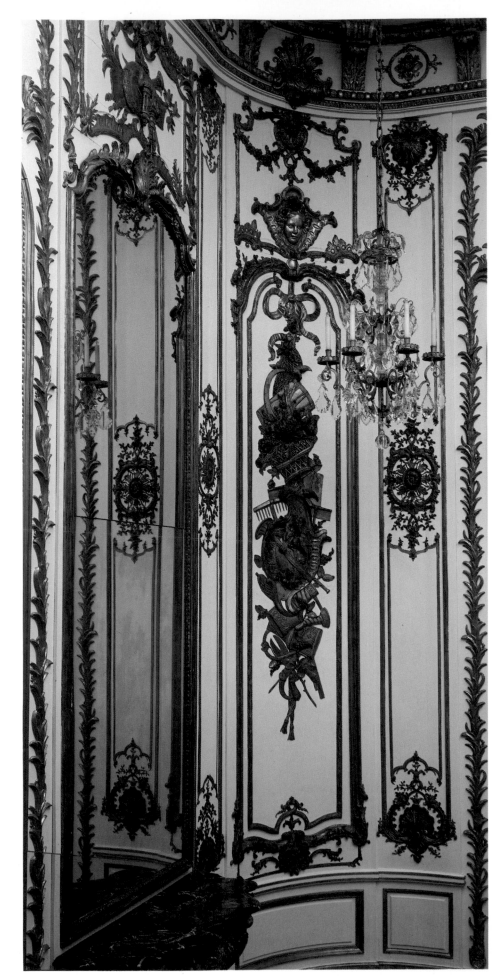

Early Louis XV Room,
ca. 1730–1735
François-Antoine Vassé
French, 1681–1736
Corner panels depicting the trophies of
the season carved, painted, and gilded
oak, H. (of room) 19 feet
The Metropolitan Museum of Art, New
York, Gift of J. Pierpont Morgan, 1906.
07.225.14

Watch Case Depicting Joseph and ▷
Potiphar's Wife
French, Blois or Paris, ca. 1645–1650
Gold and painted enamel, D. 2½ in.
The Metropolitan Museum of Art, New
York, Gift of J. Pierpont Morgan, 1917.
17.190.1573

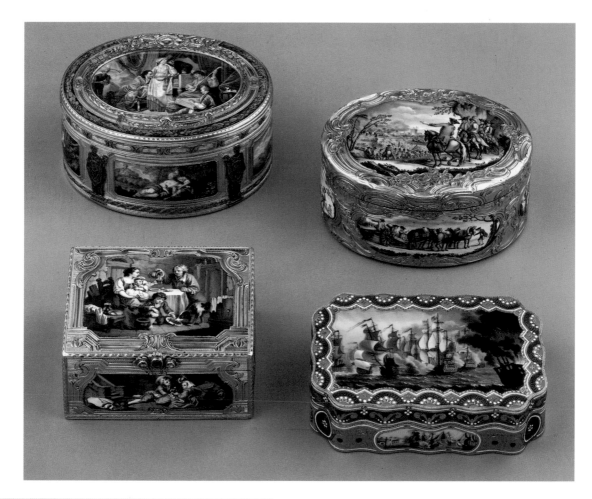

Snuffboxes

TOP LEFT:
1758–1772
Gold and enamel, H. 1¾ in.,
W. 3⅜ in., D. 2¾ in.

TOP RIGHT:
Austrian, Vienna, ca. 1770
Gold and enamel, L. 3⅞ in., D. 2¾ in.

BOTTOM LEFT:
1759–1760
Mathieu Coiny
French, 1755–1788
Carved gold, enamel, jewels, L. 2¾ in.,
D. 2⅛ in.

BOTTOM RIGHT:
ca. 1825
Jean Louis Richter
French, 1766–1841
Gold and enamel, H. 3⅜ in.,
W. 2⅛ in.
The Metropolitan Museum of Arts,
New York, Gift of J. Pierpont Morgan,
1917. 17.190.120,12,119,1146

78

Morgan's Last Years

∽

Joseph Receiving His Brothers in Egypt
Plate
French, Lyons, third quarter 16th c.
Faience
The Metropolitan Museum of Art, New
York, Gift of J. Pierpont Morgan, 1917.
17.190.1804

Mantel Clock: The Triumph of Love over Time
Movement by Lepaute Workshop; case
figures from models by Augustin Pajou
after designs by Claude Billard de
Belisard
French, 18th c.
Gilt bronze, marble, and gilt copper,
H. 37 in., W. 41 in., D. 12½ in.
The Metropolitan Museum of Art, New
York, Gift of J. Pierpont Morgan, 1917.
17.190.2126

IN THE LAST EIGHT YEARS OF MORGAN'S LIFE HE had stepped up his collecting to a dizzy pace. There is something pathetic about the aging man's race with time, his need to amass the great treasure trove that would bring the glories of the past to the edification of his relatively young nation before death caught up with him. None of his children, a son and three daughters, shared to anything like the same degree his passion for art, although his son was an ardent bibliophile and would continue to add to the rare books in the library until his own demise in 1943. But as it turned out, there simply wasn't time for Morgan Senior to realize his dream, and this had to be entrusted to his son.

To leave sixty millions worth of art to an individual would have been impossibly expensive, in terms of taxes, today, but in 1913 it was still feasible, and nobody could have undertaken the task of distributing the great accumulation more conscientiously than J.P. Morgan, Jr. The books and manuscripts, of course, remained in the library, and some 40 percent of the collections were given to the Metropolitan Museum. A much smaller amount, largely ceramics, went to the Wadsworth Atheneum, where a keen disappointment was felt. It had been natural for the friends of that institution to hope that the collector's birthplace, Hartford, would be more signally favored. But the Metropolitan had been developed to greatness under Morgan's aegis; it was located in the largest metropolis of the nation, and it was the more obvious beneficiary.

Much of the collection had to be sold. There were large cash bequests and, even in those days, some estate duties; for half of so great an estate to be invested in art was simply too much. Many of the pieces were picked up by other collectors and are happily

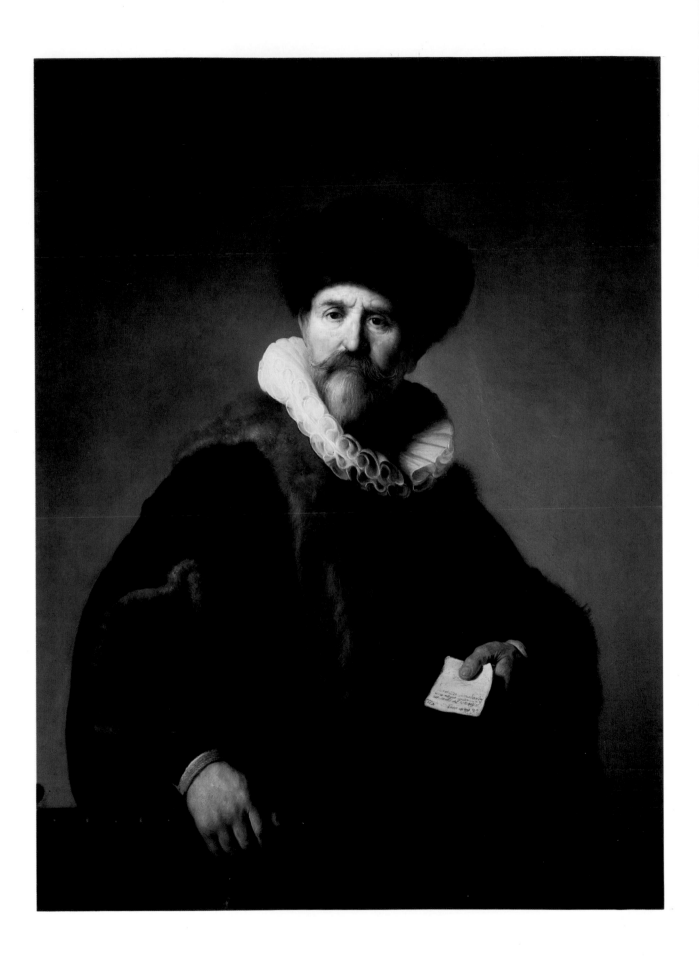

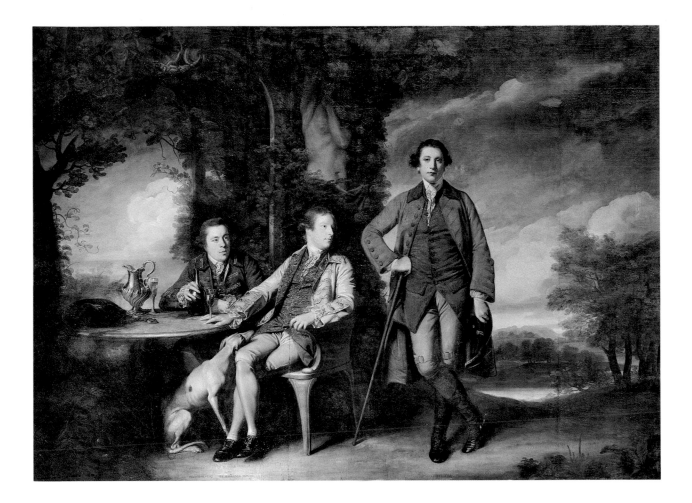

now in other museums, most notably the Frick Collection, which has the four great Fragonard panels, *The Loves of the Shepherds*, and the National Gallery of Art, which has the Mazarin Tapestry and Vermeer's *A Lady Writing*. Holbein's portrait of Erasmus came to the Metropolitan through Robert Lehmann, and Baron Thyssen owns Ghirlandaio's *Giovanna Tornabuoni,* reputedly his favorite painting. It bears the inscription, dated 1488: "Art, couldst thou but portray character and the mind, then there would be in all the world no picture more beautiful than this." In any event, the vast bulk of what Morgan collected is on view to the public.

Nicolaes Ruts, 1631
Rembrandt van Rijn
Dutch, 1606–1669
Oil on mahogany panel, 46 × 34⅜ in.
The Frick Collection, New York

Honorable Henry Fane with His Guardians, Inigo Jones and Charles Blair
Sir Joshua Reynolds
English, 1723–1792
Oil on canvas, 100¼ × 142 in.
The Metropolitan Museum of Art, New York, Gift of Junius S. Morgan, 1887.
87.16

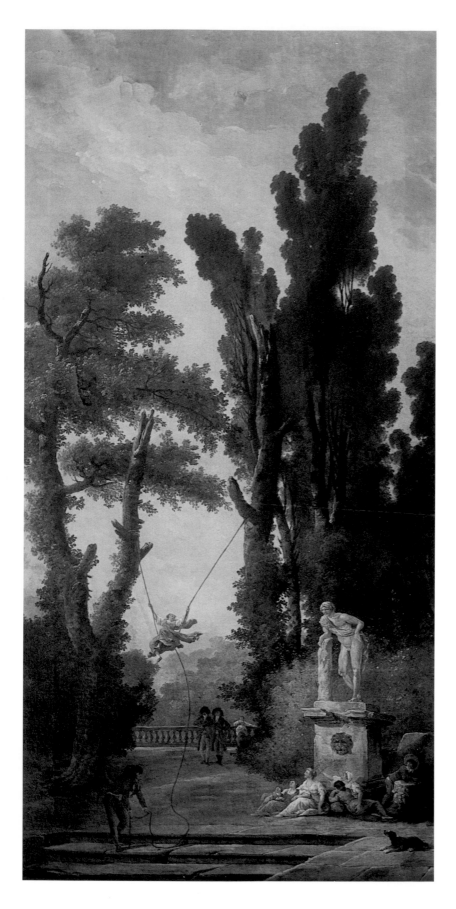

The Swing
Hubert Robert
French, 1733–1808
Oil on canvas, 68¼ × 34⅝ in.
The Metropolitan Museum of Art, New
York, Gift of J. Pierpont Morgan, 1917.
17.190.27

Portrait of the Archduke Ferdinand,
1635
Peter Paul Rubens
Flemish, 1577–1640
Oil on canvas, 45¾ × 37 in.
The John and Mable Ringling Museum
of Art, Sarasota, Florida. 626

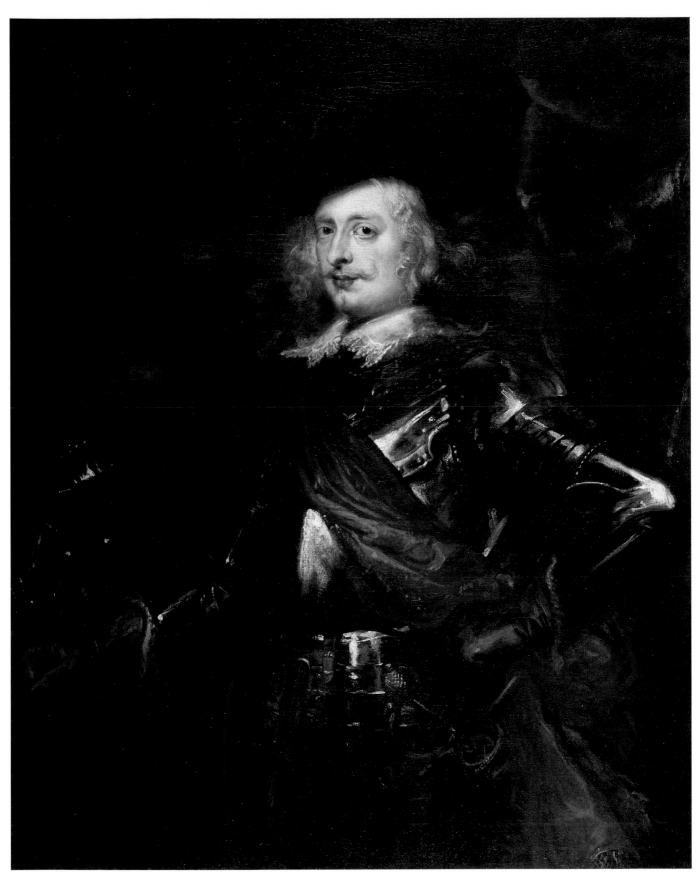

83

Ewer Decorated in Grotesques in the Style of Berain
French, Moutiers, 18th c.
Faience
The Metropolitan Museum of Art, New York, Gift of J. Pierpont Morgan, 1917.
17.190.1764

Covered Vase for a Pot-Pourri
French, Sceaux, ca. 1753–1797
Faience
The Metropolitan Museum of Art, New York, Gift of J. Pierpont Morgan, 1917.
17.190.1916

Bishop Lawrence's Memories

IT SEEMS FITTING TO TAKE LEAVE OF THE GREAT collector surrounded by his treasures. William Lawrence, Episcopal Bishop of Massachusetts, one of Morgan's close friends, has been one of the few to describe in detail the London house at Prince's Gate.

I doubt whether there has ever been a private dwelling house so filled with works of the richest art. As one entered the front door, he was still in a conventional London house, until passing along three or four yards, his eye turned and looked through the door on the left into the dining-room—in size an ample city dining-room, but in glory of color such as few other domestic dining-rooms ever enjoyed. The visitor was amazed and thrilled at the pictures: Sir Joshua Reynolds' masterpiece, *Madame Delmé and Children*, a great full-length portrait of a lady by Gainsborough, another by Romney. One's eye seemed to pierce the wall into the outer world through the landscapes of Constable and Hobbema. Behind Mr. Morgan's chair at the end of the table hung a lovely Hoppner of three children, a beautiful boy standing in the center, full of grace. Why did Mr. Morgan have this picture behind him? If you would sit in his chair, which faced the front of the house with the two windows looking out upon the hedge and trees of Hyde Park, you would discover between these two windows a narrow mirror, which enabled Mr. Morgan to have before him always the reflected portrait of the figure of the boy. As one passed through the hall, each picture was a gem. In the center of the hall, where the dividing wall used to stand, was a graceful bronze figure, turning at will upon its base, once the weather vane of the Sainte Chapelle; near it a stone figure from the Duomo of Florence; cabinets standing about with reliquaries, statuettes and other figures.

Before going into the two rooms at the back, one passed upstairs to the next floor and entered a large drawing-room at

Oval Chestnut Basket with Cover and Attached Stand
French, Sèvres, ca. 1760
Soft-paste porcelain, H. 5¼ in.
Wadsworth Atheneum, Hartford, J. Pierpont Morgan Collection. 1917.1010

Oval Basket
German, Meissen, ca. 1750
Hard-paste porcelain, soft-paste porcelain, gilt bronze, H. 27⁵⁄₁₆ in.
Wadsworth Atheneum, Hartford, J. Pierpont Morgan Collection. 1917.1234

86

Tea Set
Jacques-François Micaud
French, Sèvres, 1764
Soft-paste porcelain
Wadsworth Atheneum, Hartford, J.
Pierpont Morgan Collection.
1917.1032-1036

Meissen Group: The Judgment of Paris, ca. 1762
Attrib. J.J. Kaendler
German, 1706–1775
Hard-paste porcelain, 23 × 26 × 33 in.
Wadsworth Atheneum, Hartford,
J. Pierpont Morgan Collection.
1917.1482

OVERLEAF:
The Morgan Wing at The Metropolitan Museum of Art, New York

87

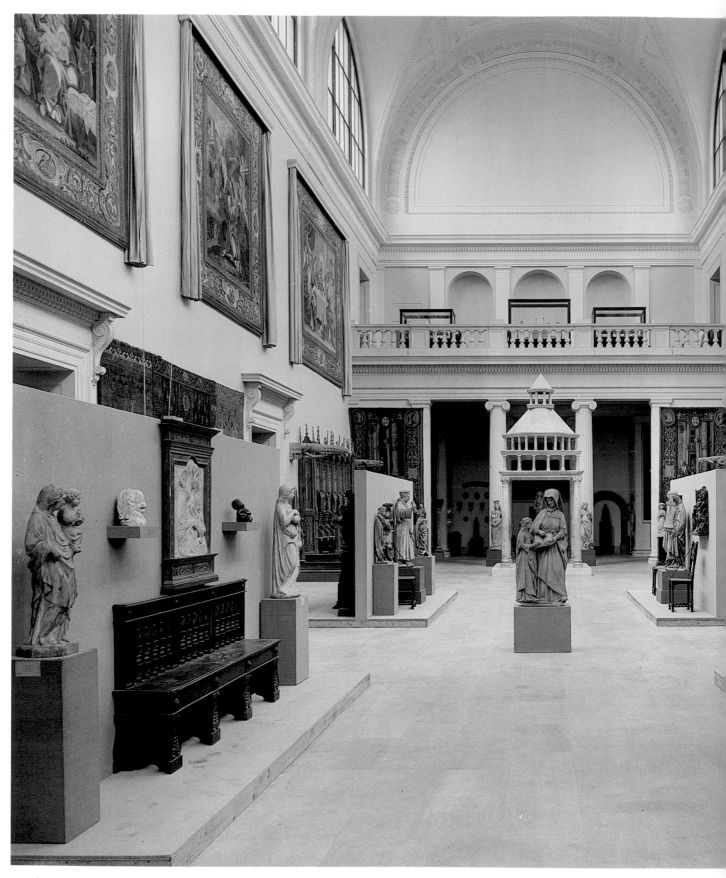

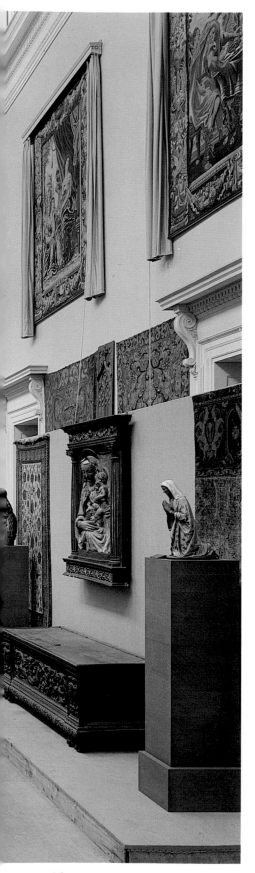

the left. The beautiful *Georgiana, Duchess of Devonshire,* by Gainsborough, looked down from the mantel. . . .

Turning from her, one's eye glanced about the room and recognized portraits made familiar through prints and engravings of a Rembrandt, a Frans Hals, a child by Velásquez, and the magnificent Van Dyck *Woman in Red and Child.* Two or three tables solid, with shallow drawers, stood in the room. As we opened one drawer after another, the wealth of beauty, color and fineness of execution of hundreds of miniatures was disclosed. As we took up one miniature after another, small and large, we realized not only the beauty of the miniature but the wealth and appropriateness of the frame, for when a miniature had been purchased with an unworthy frame, an artist had designed a frame in harmony with the style of the date of the miniature and set it round with gold and often with rows of pearls and diamonds. Each miniature with its frame seemed to compose one beautiful cluster of jewels.

Glancing at two glorious Turners, one at each side of the large door, we passed into the next room, a perfect example of Louis XVI, walls, rugs, furniture, and ornaments of the richest of that day. Across the hall to the front, we entered the Fragonard Room, whose walls were drawn in by the builder to meet the exact dimensions and designs of the panels. In the center stood a table covered with a glass cabinet filled with beautiful jeweled boxes. A glimpse of the portrait of the most attractive boy that one has ever seen, probably by Velásquez, drew one into the Louis XV room, where there were beautiful cabinets and examples of Sèvres. Portraits of Queen Anne of Austria and her brother, Cardinal Ferdinand, by Rubens, looked down upon us.

As one went down the staircase, a shelf at the landing was filled with a number of china pug dogs, such as ladies collected in their parlors some thirty years ago. Mr. Morgan's devotion to his mother's memory retained these here, although from every other point of view they were out of harmony with the surroundings.

As we stepped down the last two or three stairs, Van Dyck's *Duke of Warwick,* facing us directly, seemed to be walking toward us. Going from the hall to the two rooms at the back, we entered on the right the parlor where guests were received. Here great and graceful Gainsboroughs and Raeburns gave warmth to the atmosphere, while the furniture given by Louis XV to the King of Denmark seemed always to have belonged here. When, a few months before, Queen Alex-

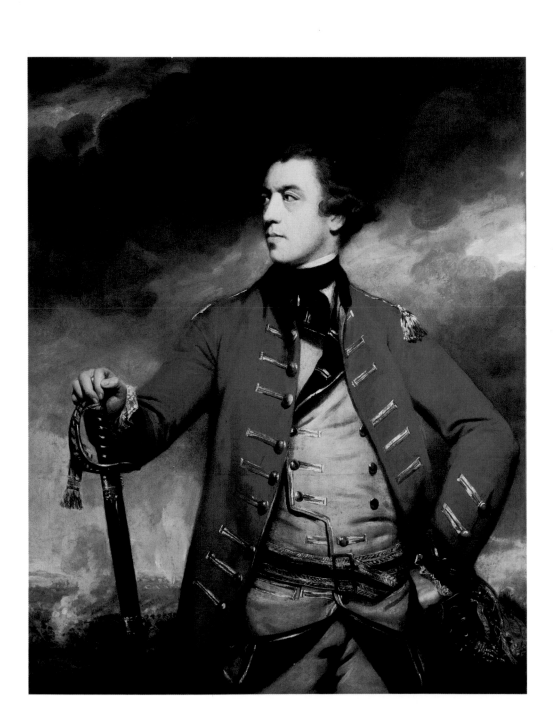

90

General John Burgoyne, ca. 1766
Sir Joshua Reynolds
English, 1723–1792
Oil on canvas, 50 × 39⅞ in.
The Frick Collection, New York

The White Horse, 1819
John Constable
English, 1776–1837
Oil on canvas, 51¾ × 74⅛ in.
The Frick Collection, New York

andra and her sister, the Empress of Russia, were being shown about the house, one of them exclaimed, "Why, there are the chairs!" and the other said, "So they are." Mr. Morgan said, "What chairs?" "Why, our brother had those chairs but they disappeared and we never knew what had become of them; they must have been sold."

The vital center of the house was the adjoining room, Mr. Morgan's own. Over the mantel hung the portrait of his father; his portrait hung also over the mantel in his library in New York. On the right of the chimney hung the portrait of Miss Croker in her beautiful youth by Lawrence, and on the mantel beside it stood a large photograph of herself at the age of 93 given by her to Mr. Morgan. How many women would have the hardihood to encourage this contrast? One must say, however, that in the revelation of the growth of character, the contrast is in favor of the old lady. On the other side of the chimney hung

THIS PAGE AND OPPOSITE:
The Morgan Collection Exhibited at The Metropolitan Museum of Art, New York, 1914

Romney's portrait of Lady Hamilton reading the news of Nelson's victory, her eyes filled with glad surprise. Diagonally across from *Miss Croker* hung Sir Thomas Lawrence's full-length portrait of Miss Farren, Lady Derby. The walls were rich with other portraits and pictures, the tables and bookcases strewn with statuettes and works of art dating from 3000 b.c. up to the twentieth century, some of them left there by dealers for Mr. Morgan to inspect, others selected by himself in Rome, Egypt and elsewhere.

At a dinner party one evening, Mrs. Talbot, the wife of the then Bishop of Southwark, said to me, "What a mass of interesting things are in this house!" I answered, "Mrs. Talbot, the most interesting thing in this house is the host."

II

THE PIERPONT MORGAN LIBRARY

THE PROJECT OF THE NEW LIBRARY BUILDING TO BE constructed as an annex to Morgan's residence on Thirty-sixth Street and Madison Avenue was launched in 1902, and Charles McKim, of the firm of McKim, Mead & White, was chosen as architect. He is supposed to have told Morgan: "When I was in Athens, I tried to insert the blade of my knife between the stones of the Erectheum, and was unable to do it. I would like to follow the example of the Greeks, but it would cost you a small fortune, and no one would see where the additional money had gone. Yet the building would last through the ages."

Morgan agreed, though the added cost would be fifty thousand dollars, and the library was built of dry masonry, which means that the stones had to be filed to make perfect joints and sealed with cement mortar by means of a shallow groove in the center.

The finished building, in the tradition of the Italian Renaissance and derived from the Villa Giulia, is a marble rectangle, centering on a portico. Twelve Doric pilasters frame the double Ionic columns of the entrance. The lionesses guarding the doors are by Edward Clark Potter, who was later to sculpt their larger mates for the New York Public Library.

The interior has all the splendor of a great Roman palace. There was no idea of correlating it in any way with the busy twentieth-century metropolis, which was firmly shut out by the great bronze doors. Morgan's determination to import the glories of old Europe for the edification of his countrymen would brook with no catering to modern tastes. The muralist Henry Siddons Mowbray, who had headed the American Academy at Rome, was selected by McKim to decorate the walls and ceilings. According to Wayne Andrews, Mowbray "did the best he could, having the scholars who would use the library in mind, to bring to life in

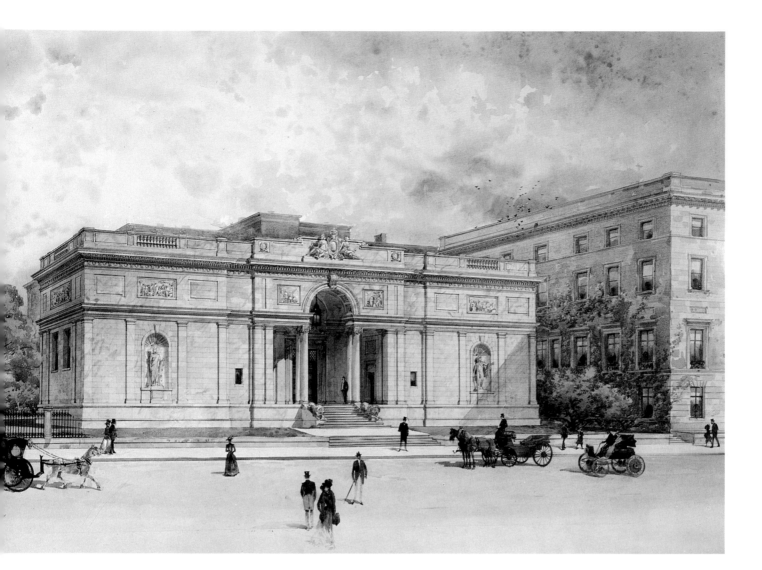

*Perspective Proposal for the Pierpont
Morgan Library*
Office of McKim, Mead & White
Drawing No. 1958.24
The Pierpont Morgan Library, New York

New York City the men of letters of the Renaissance and the gods and goddesses of Greece and Rome." His frescoes, in Andrews's opinion, were admirable for their modesty. "They fail, as well they should, to distract the attention of visitors from the other works of art. Here [in the East Room] is the engaging child Eros in a Greek Hellenistic bronze of the second century B.C.; here are two lapis lazuli columns on either side of the exuberant Renaissance fireplace; and here is the magnificent sixteenth-century Flemish tapestry telling the triumph of Avarice. Morgan himself may have been amused to note that one of the despoilers was stealing the leaves of an illuminated manuscript."

The earliest preserved color reproduction of Morgan's study, which was known as the West Room, was made in 1912 by

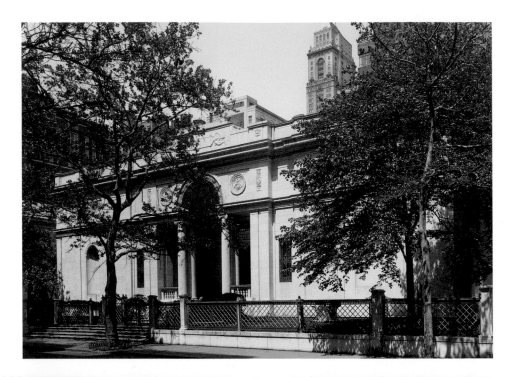

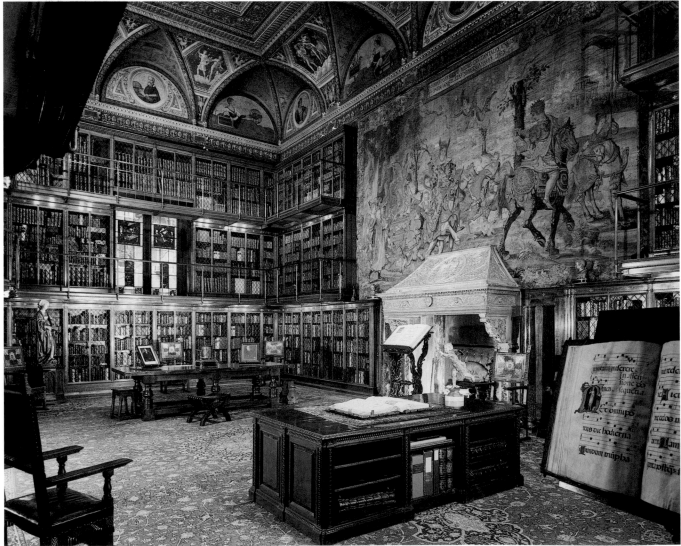

Arnold Genthe, who regarded it as the most beautiful room in America. The room as it now appears is quite different from the earliest design, which called for verdant tapestries. Because of deterioration, it was necessary to replace the original red damask, which contained the Chigi arms, with a copy.

The West Room ceiling proved to be one of McKim's most trying tasks. In 1905 an antique ceiling was purchased from a Florentine dealer, and a furniture maker was hired to piece it together. After the installation was completed, the ceiling was lowered one foot, so that it would better fit the proportions of the room.

Who would have doubted the earliest published account, in the London *Times* in 1908, that the ceiling came from the Aldobrandini Palace in Rome? This belief, which persisted over a generation, probably originated in 1907, when Morgan acquired a manuscript made for Cardinal Pietro Aldobrandini in 1593. It must have been observed that his arms resembled one of the two arms (those above the mantel) depicted on the West Room ceiling. The design and colors, however, do not agree with the Aldobrandini arms, for the stars and double battlements should be gold. Two decades later the arms above the mantel were correctly identified as those of Cardinal Ignazio Gigli of Lucca, and it was assumed that the ceiling must have come from *his* villa.

The second arms, however, located above Morgan's desk, have nothing to do with the first; they belong to the Convent of St. Stephen in Empoli. With the rediscovery of the contract with the painter who antiqued the ceiling, the mystery was cleared up. Both arms had been added by him and were copied from bookplates, with the mottoes conveniently left off. The precise origin of the ceiling thus remains unknown.

For the decorative scheme of the ceiling of the East Room, which was the original main library, Henry Siddons Mowbray proposed the following:

> The main features are eighteen lunettes. To avoid a monotony in such a series, two designs will be used. There will be nine lunettes containing female figures symbolizing History, Music, Painting, Comedy, Tragedy, and so on. In the other set, there will be portraits in circular frames of famous people who contributed to civilization, such as

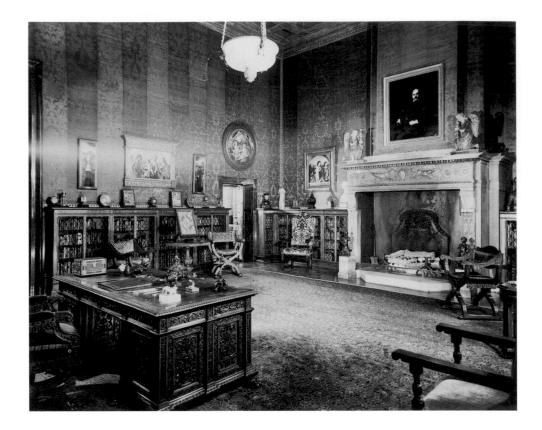

Dante, Botticelli, Galileo and others. The two sets will alternate. The style of the decoration will be late fifteenth-century, similar to that of Pinturicchio's sibyls in the Church of Santa Maria del Popolo, in Rome. The figures will be on gold mosaic, and both this and the color used will be very much suppressed, so that the work, when completed, may have the softened harmony and patina of an old room. In this view, the gold used throughout will be given as nearly as possible the tonal qualities of an old Florentine frame.

William Voelkle, curator of medieval manuscripts at the library and an expert on the building itself, has a fascinating interpretation of the zodiacal signs in the spandrels of the ceiling in the East Room in relation to Morgan's own life. He points out that a ceiling in the Farnese Palace in Rome contains a complex sky map in which the configurations of the stars have been found to coincide with those that could actually have been seen in Rome on December 1, 1466, the date of the palace builder's birth. The ceiling is, in effect, his horoscope. And it is known that Morgan was so conversant with medieval calendars that he

West Room of the Pierpont Morgan Library, 1956
Ezra Stoller
Photograph courtesy of the Pierpont Morgan Library, New York

could determine the dominical letter and golden number of a given year. Also, he had insisted on approving every detail of the library's interior, substituting, for example, a portrait of Caxton, the first English printer, for that of Gutenberg in one of the lunettes. Voelkle, with these premises, embarks on the following speculation:

> Since the zodiacal signs are not arranged in any particular order, it seemed logical to ask if the two prominently placed spandrels over the entrance doorway might not have some special significance. They are the only stars under which Morgan could walk, and they are isolated from the rest.
>
> On the left are Venus, and Cupid, who is seated on a ram, the sign of Aries. On the right, the Twins, the sign of Gemini, are accompanied by Mercury. The fact that Morgan's sign was Aries (he was born on 17 April 1837), suggests that this line of inquiry may be fruitful. While it could be argued that this would be a suitable place for Aries, which is the first sign of the zodiac, it may be more difficult to explain the placement of Gemini, which is not

the second, but the third. As it happens, Morgan's second and long-lasting marriage to Frances Louisa Tracy took place under Gemini, on 31 May 1865. Moreover, the wedding took place on a Wednesday, the day of Mercury, who is shown with the sign. Venus, who holds two white doves, and accompanies the ram, was also the goddess of love, and presided over marriage ceremonies.

Aries and Gemini, the two most important signs in Morgan's life, are seemingly in a world of their own, for they are also separated from the others by two non-zodiacal spandrels. One depicts Pluto abducting Persephone to the underworld; in the other Mercury is seen bringing Persephone to the upper world. Next, I investigated the two signs on the opposite wall, above the mantel and center lunette, which depicts Dante.

Since the sign for Aquarius was on the same axis as Gemini, I thought that it too might refer to an event in a woman's life. Morgan's first marriage was short-lived, for Amelia "Mimi" Sturges, his childhood sweetheart, died on 17 February 1862, a little over four months after their marriage. That this sad event occurred under Aquarius was not as astonishing as the location of the sign, which was above the lunette representing Tragedy.

Directly opposite Morgan's own sign is Libra, represented by scales, and Mars and Venus. Since the signs on the other axis referred to events connected with his wives, I assumed that Libra was somehow connected with Morgan himself. The clue for the sign, found in a book devoted to one of New York's exclusive dining clubs, was an illustration showing Morgan and a set of scales, the symbol for Libra. The dining club, called the Zodiac of 12, was founded in 1868. Membership was limited to twelve, and new members adopted the signs left vacant by death. The members were called signs and addressed each other as brothers.

According to the club's minutes, Morgan was elected to fill the vacancy caused by Brother Libra's death, on 28 November 1903, well before the decorative scheme for the spandrels was fixed. Morgan's adopted sign, Libra, occurs, almost whimsically, above Comedy. After Morgan's death in 1913, his son became the new Brother Libra. The positions of the remaining signs seem not to have been significant.

III

THE
MASTERPIECES

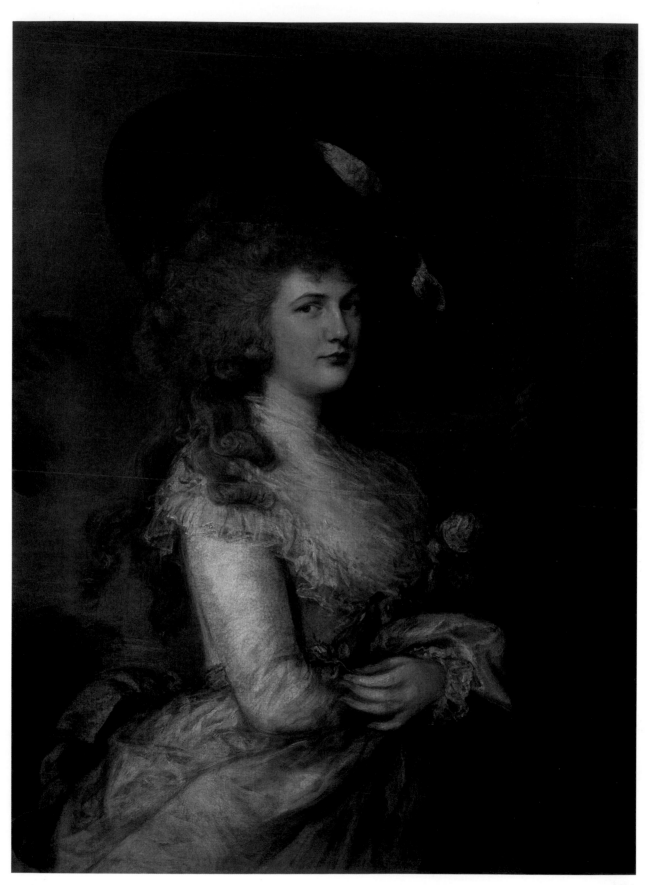

Gainsborough's *Duchess of Devonshire*

Before breaking up his father's collections for sale or distribution to museums, J.P. Morgan, Jr., proposed to his sisters that each child should choose a few favorite paintings to keep. The family showed a unanimous preference for eighteenth-century English portraits.

Anne Morgan, whose forceful personality was closer to her father's than those of the others and who was to make her name in organizing French relief during and after the First World War, selected Gainsborough's portraits of Lady Gideon and Miss Willoughby and Raeburn's *Lady Maitland*. Juliet, who married but later divorced William P. Hamilton, a descendant of Alexander, chose Romney's portraits of Lady Hamilton and Mrs. Scott Johnson and Gainsborough's *Mrs. Tenant*. J.P., Jr., kept Lawrence's *Miss Farren* and Raeburn's *Miss Rose,* while Louisa, who married Herbert Satterlee, her father's biographer, took Reynolds's portraits of the duchess of Gloucester and Lady Betty Delme, Hoppner's *Godsal Children*, and Gainsborough's *Duchess of Devonshire.*

The last mentioned may have been for a time the most famous portrait in the world, but when it first came to light, in 1841, purchased by the London dealer John Bentley from one Miss Maginnis, an old schoolmistress, for fifty-six pounds, it was not even known to be of the duchess. It had once been a full-length likeness, but Miss Maginnis, perhaps needing it for a smaller wall space, had cut off and burned the part below the knees. Bentley sold it to the collector Wynn Ellis for the same sum. He suspected its greater value but had not wanted to make a profit from a close friend. Ellis had an engraving made of the picture, which was widely circulated, bringing it to the attention of experts who identified it as Georgiana, duchess of Devonshire, and by Gainsborough. The large, wheel-shaped hat with plumes,

The Duchess of Devonshire
Thomas Gainsborough
English, 1727–1788
Oil on canvas
Private Collection, New York

a design of Mademoiselle Bertin, mantua maker for Marie Antoinette, enabled the date of the picture to be established as 1785. The artist had not been satisfied with his work ("The duchess is too hard for me!" he is supposed to have exclaimed) and had refused to deliver it to Chatsworth. Later, it was supposed to have been destroyed.

On Ellis's death in 1875 the painting was auctioned at Christie's for more than ten thousand pounds and achieved huge publicity. The purchaser, Sir William Agnew, put it on public display in the Agnew Galleries, where it drew large crowds, and Junius Morgan arranged to buy it for his son who "had begun collecting pictures in New York."

Unfortunately, the picture had also attracted the attention of one Adam Worth, a notorious American burglar who had settled in Cambridge, Massachusetts. One of Worth's gang had just been extradited from France to England on a charge of circulating forged bank notes. Worth and his cohort Jack Phillips, known as "Junka," decided to steal the duchess from Agnew's gallery and hold her as a ransom for the release of their imprisoned pal. This they did very easily by prying open a second-story window on a foggy night, cutting the duchess from her frame, rolling her up, and carrying her off. They then slit off a tiny piece of canvas and sent it to Sir William to back up their ransom threat. But as Scotland Yard refused to allow Sir William to cooperate and as Worth's captive cohort was anyway released on a technicality in the extradition process, the picture became a white elephant in the hands of the crooks and disappeared from sight until 1901. By then Worth, old and ill, had returned to America, and secret negotiations were opened between him and a Pinkerton detective. Sir William Agnew's son, who, outside the United Kingdom, was willing to pay a fee to recover the painting, was mysteriously summoned to Chicago, where an unknown messenger delivered the duchess to him, in good condition, at his hotel.

Pierpont Morgan, a quarter of a century after his father's offer to Agnew, now completed the transaction, though at a far greater price, $150,000. It was anyway less than a third of what Henry E. Huntington paid twenty years later for another Gainsborough, *The Blue Boy*.

Raphael's
Colonna Altarpiece

A great Raphael was a principal goal of nineteenth-century collectors, comparable to a Van Gogh today. Fine examples were hard to find in the galleries and auction markets, so much so that when the king of Saxony threatened to balance his civil list by the sale of a Raphael in the Dresden Museum, the crown princess of Prussia, then visiting her mother, Queen Victoria, in London, telegraphed to Bismarck, who at once informed the Saxon monarch that a Prussian regiment would occupy the museum if the project were not canceled.

Raphael's famous altarpiece, *Madonna and Child Enthroned, with Saints,* had been painted for the nuns of Sant'Antonio of Padua in Perugia in 1505. In 1677 the indebted sisters were induced to sell it to a Perugian nobleman from whom it passed to the Colonna family in Rome, where it remained for more than a century until purchased by King Francis I of the Two Sicilies. It was a favorite picture of his grandson, Francis II, who took it with him into exile when he was deposed in 1860, but seven years later his financial condition required him to offer it for sale in Madrid. The director of the National Gallery in London informed Prime Minister Disraeli, who simply said, "Get it." By now, however, the Empress Eugénie had evinced an interest, and the picture was sent to Paris on approval, where it was still unbought when war with Prussia broke out in 1870. After the fall of the Second Empire Francis II somehow managed to put his financial house in order, and the picture was removed from sale, not to be offered again until his death in 1894. At this point the National Gallery, which had recently spent seventy thousand pounds for the duke of Marlborough's *Ansidei Madonna,* was no longer in the market for a Raphael, and, besides, the picture had been supposedly damaged by an injudicious repainting. Morgan was able to acquire it, and the damage turned out to be superficial.

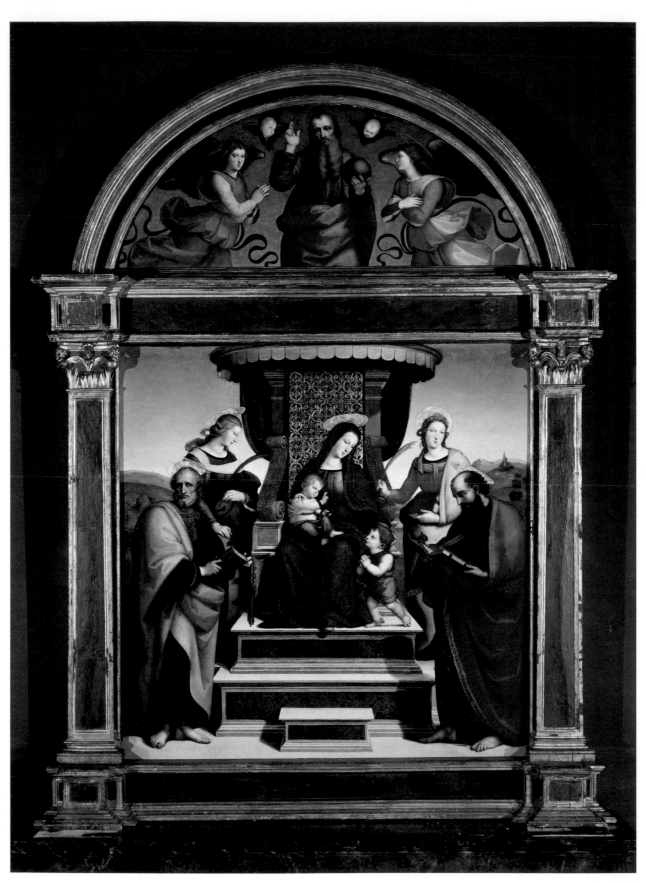

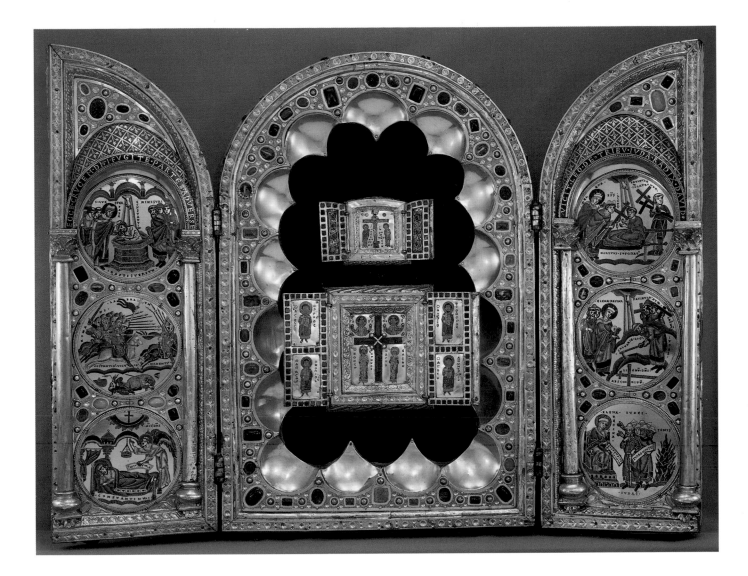

Madonna and Child Enthroned, with Saints
Raphael (Raffaelo Sanzio or Santi)
Italian, 1483–1520
Altarpiece from the choir of the Convent of Sant 'Antonio di Padova, Perugia
Tempera, oil, and gold on panel. Main panel, overall, 67⅞ × 67⅞ in., lunette, overall, 29½ × 70⅞ in
The Metropolitan Museum of Art, New York, Gift of J. Pierpont Morgan, 1916. 16.30 a,b. Photograph by Geoffrey Clements

The Stavelot Triptych
Mosan and Byzantine, ca. 1156–1158
The Pierpont Morgan Library, New York

This famous triptych, a reliquary for a piece of the true cross and one of the masterpieces of Romanesque art, was a late acquisition of Morgan's, having been purchased from Durlacher Brothers in London in 1910 on the advice of Sir Charles Hercules Read of the British Museum. It is believed to have been commissioned by Wibald, abbot of the Imperial Benedictine Abbey of Stavelot, in Belgium, from 1130 to 1158. Wibald, like many great clerics of his era, was also a statesman; he acted as advisor to three Holy Roman emperors and was sent by Frederick I Barbarossa on two missions to the court of Manuel I Comnenus in Constantinople, on the first of which he negotiated the marriage of Frederick with Comnenus's niece. It may have been on one of these embassies that he received the gift of the two small triptychs with cloisonné enamels enshrined in the central panel that make the artifact a rare example of the art of Byzantium combined with that of the contemporary West. The larger enamel shows the emperor Constantine with his mother, Helena, reputed discoverer of the true cross; the smaller, the Crucifixion.

The six champlevé enamel roundels that adorn the wings of the main triptych are among the finest examples of Mosan (area by the Meuse River in Belgium) art. They show scenes in the story of the finding of the cross: the dream of Constantine, his defeat of Maxentius, his baptism, Helena's interrogation of the Jews as to the location of the cross, the finding of the three crosses, and the testing of the true one.

Morgan bought a great deal of enamel, both of the cloisonné and champlevé methods. In cloisonné enamels the compartments are made with thin plates set on edge upon a foundation plaque, and into these the variously colored enamels are put in a powdered state and then melted in a furnace. In champlevé ("raised field") enamels the compartments are excavated in the substance of the foundation plaque itself. It has been said that the cloisonné method, the one preferred by the Byzantines, is more adapted to their painstaking, meticulous work habits. These enamels are like their jewels and mosaics: grave, sedate, idealistic, and governed by serene convention. The champlevé method, on the other hand, produces livelier pictures, more appropriate to spirited Westerners.

Roger Fry, in his introduction to a book on the Byzantine enamels in the Morgan collection, has this to say of the delicate

art that flourished between the tenth and thirteenth centuries:

> When the furnace and the burnisher have completed their respective tasks, nothing but burial in damp earth can impair it. To minds oppressed by the evanescence of beauty in the things of man's creation, enamel has thus often appeared the perfect form of painting, the one form which can preserve the artist's work through an infinity of coming time almost exactly as it left his hands. It was by this impressive power of resistance that it charmed the poet who thirsted after the abiding splendor and beauty, demanding that the substance in which they are embodied should hold them imperishable in a world of decay; let the hard gem perpetuate the form and the fused glass the color.

The Illuminated Manuscripts

Perhaps the greatest treasure of the Pierpont Morgan Library is its collection of medieval illuminated manuscripts. Illumination refers to the decoration and embellishment of initials and pages of manuscripts with bright colors and gold leaf.

Morgan's collection had its birthday on July 4, 1899, when he received a cable from his nephew in London, Junius Spencer Morgan, who frequently advised him in art purchases: "Can obtain for you famous gospels, ninth or tenth centuries, gold and jewel binding of time. Treasure of great value and interest, reported unequalled England or France."

The price was ten thousand pounds, which Morgan gladly paid to obtain the Lindau Gospels, bound in a gold-and-jewel-encrusted cover, named for the convent in Lindau, Germany, where the manuscript, of Swiss origin, remained for many years.

Morgan for the rest of his life continued to add to the great collection so started. Not all of it is of a religious character. There was a need in medieval times for illustrated scientific and medical books, to which we owe the herbal guides and bestiaries, with their wonderful pictures of plants and animals.

William Voelkle, curator of this department at the library, has summarized the utility of the collection:

> Illuminated manuscripts are among the best examples of mediaeval and Renaissance painting available to us today. Protected by their bindings, and spared the deterioration caused by the elements which have taken their toll on frescoes, panels and similarly exposed works of art—the

*John the Evangelist, John the Baptist
Preaching, Marriage Feast at Cana*
From a Gospel for Contessa Matilda of
Tuscany, M. 492, f. 83v
Polirone near Mantua, end of the 11th c.
The Pierpont Morgan Library, New York

◁ *Biblical Scenes: Saul with the Army
of Israel; Combat of David and
Goliath; David Beheading Goliath;
Saul Attacking David; David
Anointed; Killing of Absalom; David
Mourning Absalom*
From a Bible leaf illuminated at St.
Swithin's Priory, Winchester, M. 619v
English, last quarter 12th c.
The Pierpont Morgan Library, New York

Jeweled Cover
From the Lindau Gospels, M.1
Carolingian, 9th c.
The Pierpont Morgan Library, New York

112

*The Seven-Headed Dragon Attacked
by the Family of the Woman; John
Observes the Seven-Headed Beast of
the Sea*
From the *Apocalypse Cycle*, illuminated
in Westminster Abbey or in the Abbey
of St. Albans, M. 524, f. 10
English, ca. 1250
The Pierpont Morgan Library, New York

*Blanche of Castile and Her Son, St.
Louis: The Author and the Scribe*
From a moralized Bible made for
Blanche of Castile and Louis, M. 240,
f. 8
French, prob. Paris, ca. 1235
The Pierpont Morgan Library, New York

115

113

illuminations have retained their original colors and brilliance. Consequently, such illuminated manuscripts have become important documents for the history of painting and the use of color. In addition, they also provide valuable insights into how people lived during different periods of history, what they read and thought, what they wrote, and the techniques they used to decorate and bind their books.

Of course, for a long time it was difficult, if not impossible to make the collection available to any but a few scholars. Bernard Berenson said:

> Illuminated manuscripts are not easily accessible to the public, and for good reasons. Most of them are still in codices and can be shown only two pages at the time. There is no other way unless the leaves are extracted and exhibited separately. This is not to be recommended as it takes away from their character as book illustration and besides makes them liable to lose or change colour or to fade away from permanent exposure to the light. Many of them are too fragile, indeed so fragile that most keepers of illuminated manuscripts would prefer to keep them like houris in a harem.

Fortunately today almost perfect reproductions in the form of slides or microfiche have made the Morgan collection illuminated manuscripts and miniatures available to universities, museums, and libraries.

Related to the illuminated manuscript collection are the thirty-five playing cards from a tarot pack that Morgan acquired in 1911 through the Parisian firm of Hamburger Frères. The cards may have been made for Bianca Maria Visconti and Francesco Sforza, whose marriage in 1441 united the two ruling families of Milan. Morgan's interest in cards became a matter of history when he played his favorite game of solitaire in his library during the Panic of 1907 while the leaders of the financial community, one by one, came in to suggest remedial measures. He kept the tarot cards by his desk in a late-fourteenth-century French *cuir bouilli* casket decorated with scenes of couples playing chess and exchanging hearts and rings.

Such early tarot cards are extremely rare; no full pack is known. The Visconti-Sforza cards are attributed to the Cre-

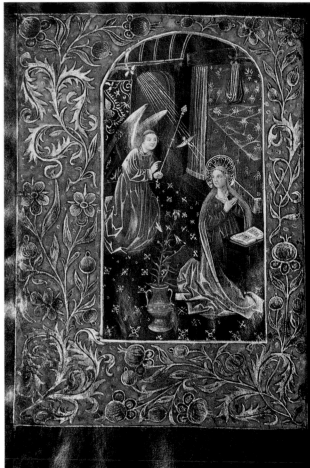

Annunciation
From a book of hours, illuminated in Bruges, M. 493, f. 29v
Belgian, last third of 15th c.
The Pierpont Morgan Library, New York

◁ *Last Supper, in the Initial C*
From Graduale, M. 653, f. 4
Illuminated by Silvestro dei Gherarducci
Italian, Florence, last third 14th c.
The Pierpont Morgan Library, New York

Marriage of the Virgin: Eight Medallions with Scenes from Her Life
From a book of hours, illuminated by several artists in Paris, M. 453, f. 30v
French, ca. 1425–1430
The Pierpont Morgan Library, New York

118

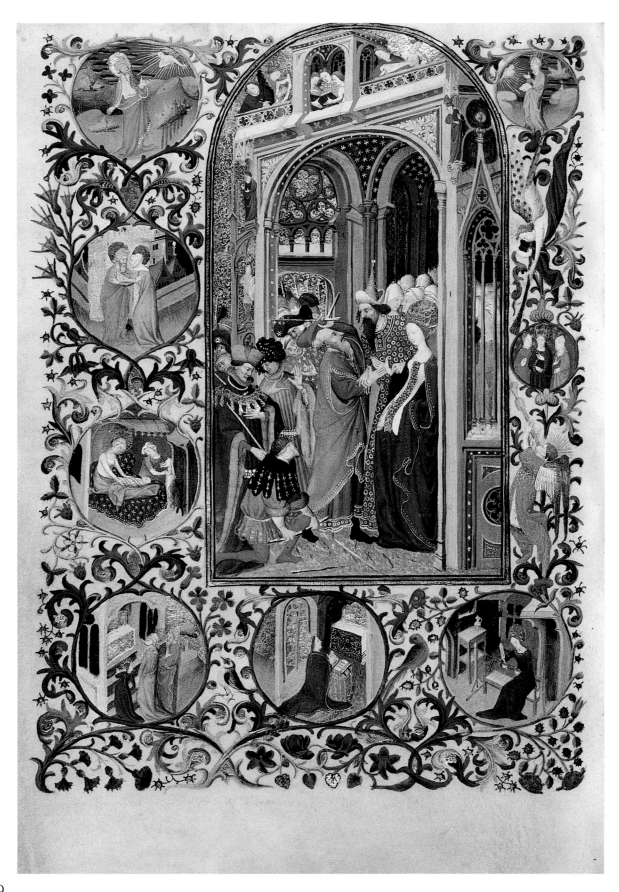

119

Adam and Eve
From *Manafi Al-Hayawan (Uses of Animals)*, M. 500, f. 4v
Ibn Bakhtishu
Persian, Maragha, ca. 1295
The Pierpont Morgan Library, New York

May
Calendar illustration depicting a
boating party.
From the *Da Costa Hours*, M. 399,
f. 6v
Illuminated by Simon Bening
Flemish, Bruges, ca. 1515
The Pierpont Morgan Library, New York

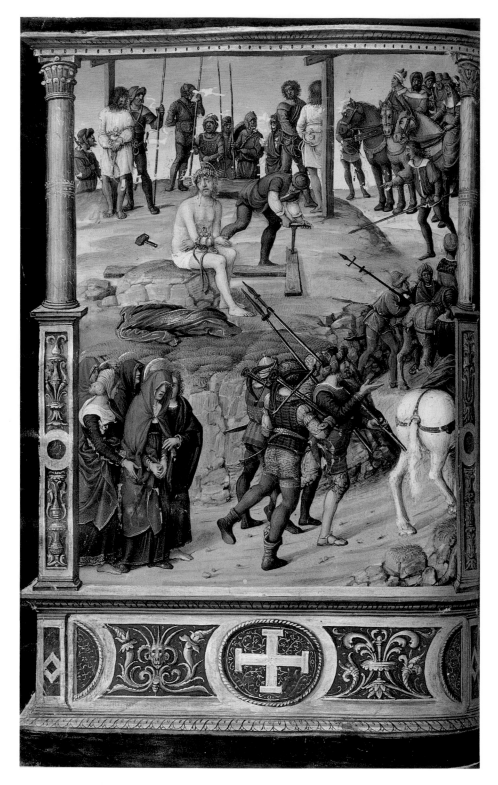

Christ Seated on Calvary, Awaiting Crucifixion
From the *Lallement Missal*, illuminated by Jean Poyet for Guillaume Lallement in Tours, M. 495, f. 85v
French, ca. 1495
The Pierpont Morgan Library, New York

Frontispiece with Medallion Depicting St. Jerome at His Desk, Florence in the Background, and King Matthias Corvinus Kneeling at the Lower Left
From a manuscript containing Didymus Alexandrinus's "De Spiritu Sancto" and other texts. M. 496, f. 2
Illuminated by Monte di Giovanni for King Matthias Corvinus of Hungary
Italian, Florence, 1488
The Pierpont Morgan Library, New York

The Betrayal of Christ in the Initial Q
From the *Windmill Psalter,* illuminated in England, M. 102, f. 52v
Prob. London, ca. 1290
The Pierpont Morgan Library, New York

123

Creation
From the *Farnese Hours*, M. 69,
f. 59v
Written by Francesco Monterchi, signed
by illuminator Giulio Clovio for
Cardinal Alessandro Farnese
Italian, Rome, 1546
The Pierpont Morgan Library,
New York

Sun and *Last Judgment*
Two cards from a tarot deck made for a
member of the Visconti-Sforza family in
Milan. M. 630; 13,14
Italian, Milan, ca. 1450
The Pierpont Morgan Library, New York

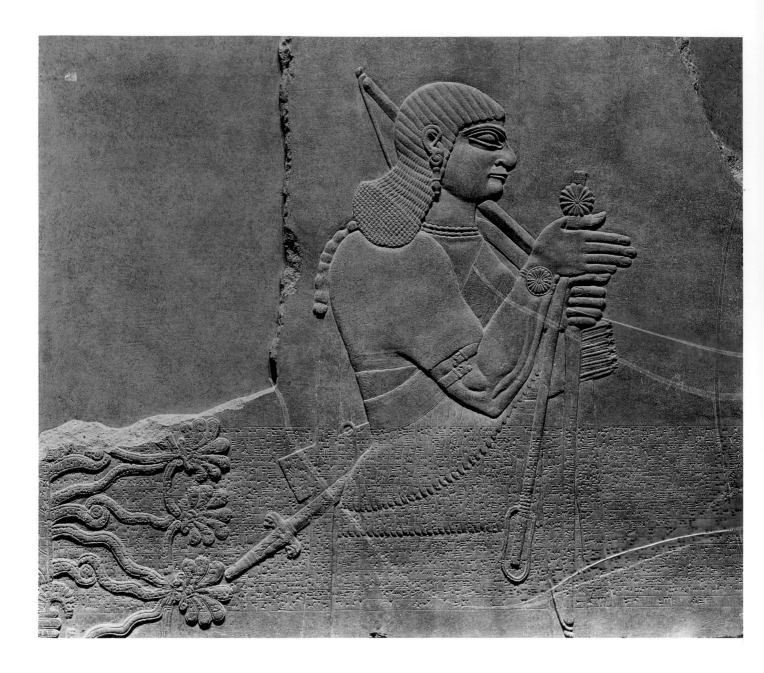

Arms-Bearer of the King
Assyrian bas-relief from the Palace of
Ashur-nasir-apal II (885–860 B.C.)
Nimru, Iraq, 9th c. B.C.
Alabaster
The Metropolitan Museum of Art, New
York, Gift of J. Pierpont Morgan, 1917.
17.190.2079

The Assyrian Slabs

In 1912 Morgan loaned to the Metropolitan (later given by his son) three alabaster slabs in bas-relief from the palace of Ashur-nasir-apal, who ruled Assyria from 885 to 860 B.C. The slabs were part of the decoration of a great hall—since almost completed by other benefactors of the museum—showing the monarch taking part in religious services and battle scenes. An inscription reads:

> The priest of Ashur, the darling of the gods, Ellil and Enmastu, the beloved of the gods Anu and Dagan, the powerful one among the gods, the mighty king, the king of hosts, the king of Assyria, the valiant hero who by the assistance of Ashur his lord goes forth, and among the princes of the four quarters of the world does not have a rival.

The slabs were unearthed by an Englishman, Austen Henry Layward, working for the British Museum from 1849 to 1851.

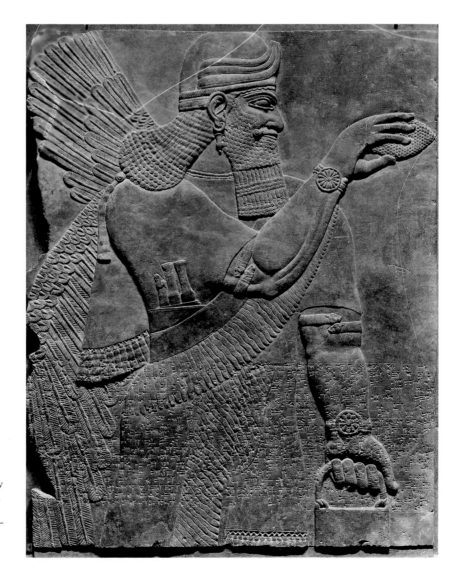

Winged Being Pollinating the Sacred Tree
Assyrian bas-relief from the Palace of Ashur-nasir-apal II (885–860 B.C.)
Nimru, Iraq, 9th c. B.C.
Alabaster
The Metropolitan Museum of Art, New York, Gift of J. Pierpont Morgan, 1917.
17.190.2081

127

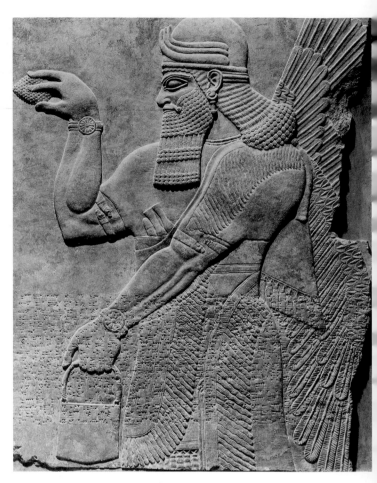

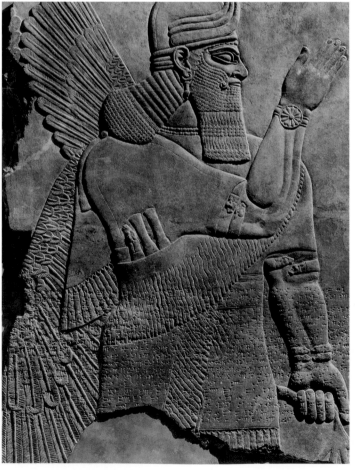

Winged Being Pollinating the Sacred Tree
Assyrian bas-relief from the Palace of Ashur-nasir-apal II (885–860 B.C.)
Nimru, Iraq, 9th c. B.C.
Alabaster
The Metropolitan Museum of Art, New York, Gift of J. Pierpont Morgan, 1917. 17.190.2077

◁ *Winged Being Worshiping*
Assyrian bas-relief from the Palace of Ashur-nasir-apal II (885–860 B.C.)
Nimru, Iraq, 9th c. B.C.
Alabaster
The Metropolitan Museum of Art, New York, Gift of J. Pierpont Morgan, 1917. 17.190.2078

Winged Being Pollinating the Sacred Tree
Assyrian bas-relief from the Palace of Ashur-nasir-apal II (885–860 B.C.)
Nimru, Iraq, 9th c. B.C.
Alabaster
The Metropolitan Museum of Art, New York, Gift of J. Pierpont Morgan, 1917. 17.190.2082

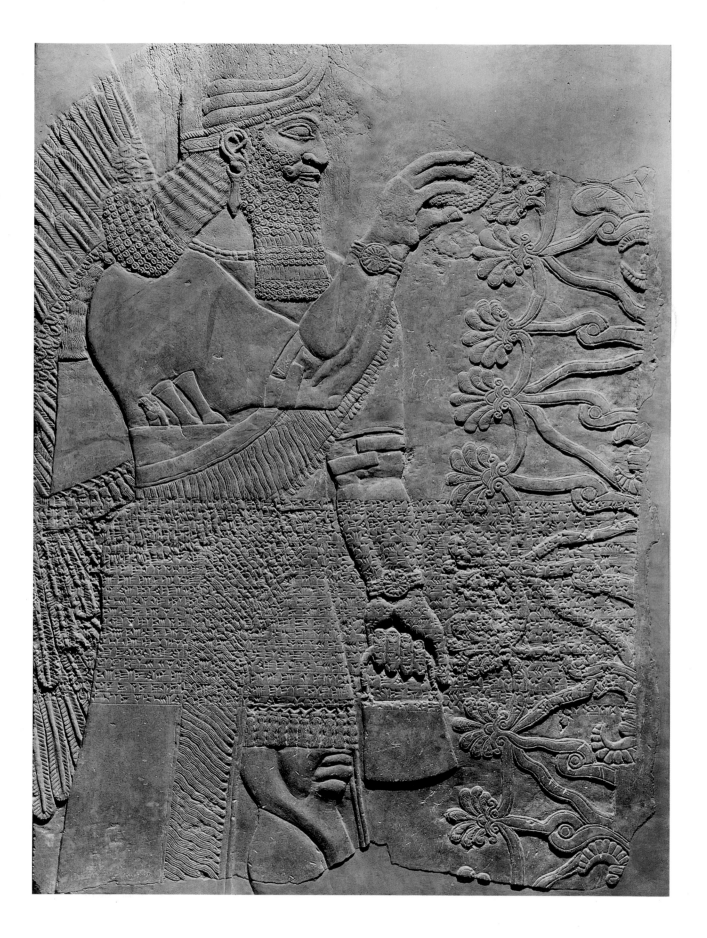

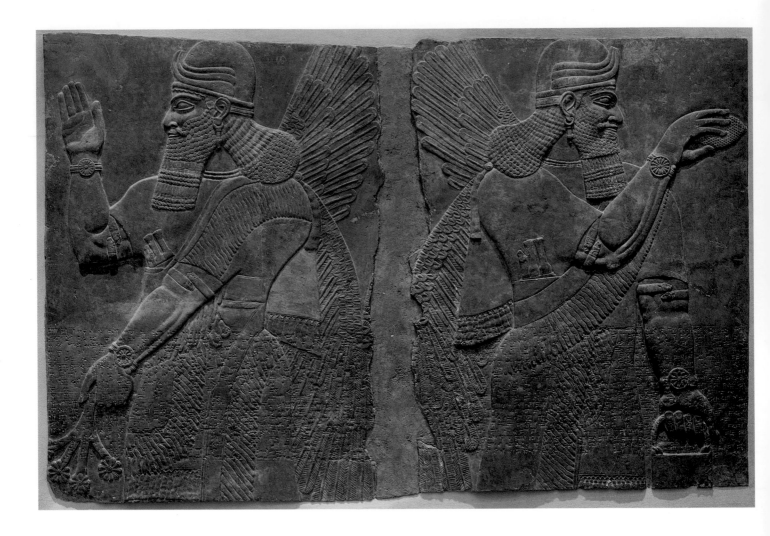

Winged Being Worshiping
Parts of a slab of Assyrian bas-relief
from the Palace of Ashur-nasir-apal II
(885–860 B.C.)
Nimru, Iraq, 9th c. B.C.
Alabaster
The Metropolitan Museum of Art, New
York, Gift of J. Pierpont Morgan, 1917.
17.190.2080

Fragonard's *Loves of the Shepherds*

The four panels by Fragonard, *The Loves of the Shepherds*, are now one of the glories of the Frick Collection in New York. The first, entitled *The Pursuit*, shows an ardent youth, very much resembling the young Louis XV, invading the garden bower of a beautiful and startled girl. *The Meeting, The Lover Crowned*, and *Love Letters* follow his successful suit as their titles imply. The panels were executed for Madame du Barry's Château de Louveciennes in 1771–73 at the height of her royal favor but were refused—for what reason no one knows. Some art historians have thought that the king may have been displeased by recognizing himself in the lover, but as he was old at the time, it seems more likely that he would have been flattered by this reminder of his former good looks. Georges Wildenstein has suggested instead that the subjects were too conventional for his jaded palate. Or perhaps the panels simply didn't fit into the wainscotting. At any rate, Fragonard sent them to Grasse to decorate the house of a Monsieur Maubert, whose heirs eventually offered them to the Louvre at a price that the museum was unable to meet. The popular dramatist Victorien Sardou then sought to persuade the family to give the panels to the Louvre, hoping to receive the Légion d'Honneur for his pains. But this, too, failed, and the panels ended up at Wertheimer's in London where they were sold to Morgan.

OVERLEAF:

The Loves of the Shepherds, 1771–1773
Jean-Honoré Fragonard
French, 1732–1806
The Frick Collection, New York

The Pursuit
Oil on canvas, 125⅛ × 84⅞ in.

The Meeting
Oil on canvas, 125 × 96 in.

The Lover Crowned
Oil on canvas, 125⅛ × 95¾ in

Love Letters
Oil on canvas, 124⅞ × 85⅜ in.

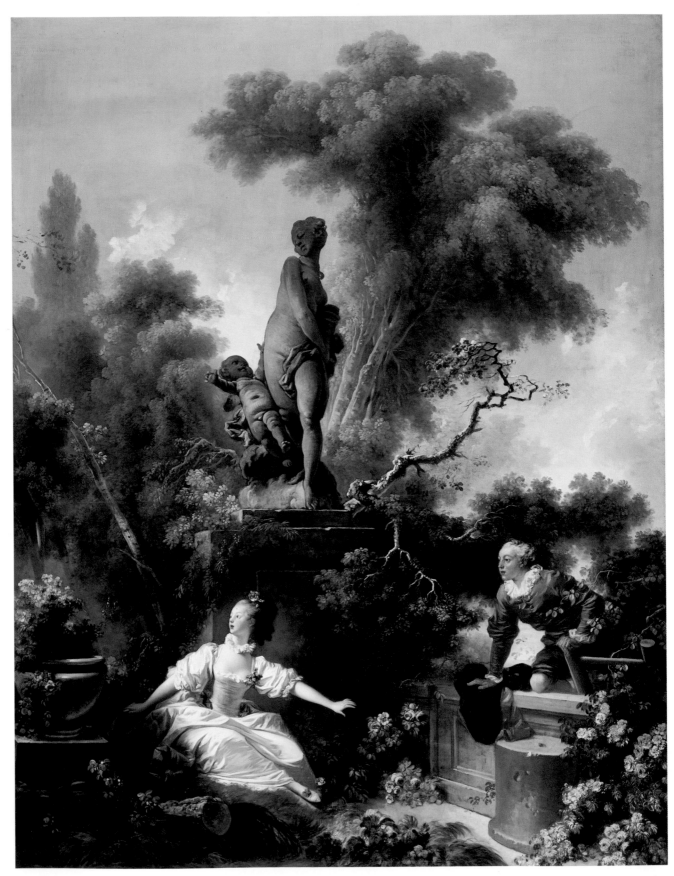

132

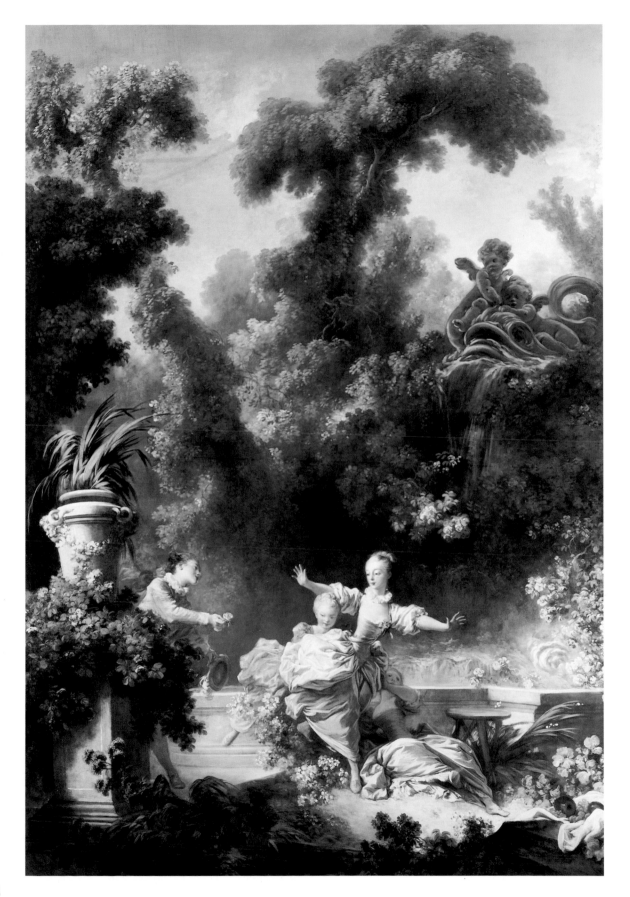

133

134

135

The portrait at the Metropolitan now identified simply as that of "A Lady," by an unknown sixteenth-century British painter, was acquired by Morgan in 1909 from the collection of the earl of Sheffield at Sheffield Park, Sussex. The lady, clad in a richly embroidered white dress, with a lace ruff and headdress, holding a fan, was then thought to be Queen Elizabeth, and indeed the resemblance is striking. Another portrait discovered in Sussex, obviously of the same sitter, was also believed to be of the queen. But in the 1960s the experts were questioning both identifications. The jewel worn by the lady was not found in any inventories of the royal jewelry. And the queen had never been painted wearing so *few* jewels. Might it not be Elizabeth, daughter of the 11th Lord Zouche? Or even a repainted portrait of Anne of Denmark, consort of James I? The museum decided to demote the lady. But it still seems to this observer that for a young woman of court circles who had the red hair, aquiline nose, and pallor of her virgin sovereign to have herself painted in quite so regal a pose would have been risking a charge of lèse-majesté.

The Annunciation, now attributed to a follower of Rogier van der Weyden, was thought to be the work of the master himself when Morgan acquired it in 1908. It had originally been in the collection of the earls of Ashburnham, and when it was first offered for sale in 1903, no less an authority than Bernard Berenson urged Isabella Stewart Gardner to buy it as a Rogier. But the experts, finding the execution of the painting lackluster and its effect wooden, began to doubt that it was by Rogier. Some suggested that it might be a work of his later and declining years, others that it could be by Hans Memling—the face of the Virgin suggested the latter's touch. But the strongest argument against its being by Rogier was that the arms on the window and repeated in the pattern on the rug are those of the family of Clugny. Ferry de Clugny, an enthusiastic patron of the arts, became bishop of Tournai in 1474, a decade after Rogier's death, and there is some reason to believe that the painting was commissioned at the time of his consecration.

Portrait of a Lady
Unknown British painter, 16th c.
Oil on wood, 44½ × 34¾ in.
The Metropolitan Museum of Art, New York, Gift of J. Pierpont Morgan, 1911. 11.149.1

137

The Miniatures

It is curious that Morgan's son should have elected to sell his father's collection of miniatures at auction at Christie's in London in 1935, where they brought, for a time of economic depression, what was considered the huge sum of $340,000, for one could make the argument that, after rare books and manuscripts, these small portraits were the senior Morgan's favorite acquisitions. At least such was the opinion of Dr. George C. Williamson, who catalogued the collection and advised Morgan on many of the purchases, and who shared his patron's passionate enthusiasm for this form of art, which made them friends as well as associates.

The art of the miniature arose from the medieval practice of painting portraits on manuscripts. These small likenesses came to be attached to treaties and other official documents handed to ambassadors so that their principals might become acquainted with the features of the sovereigns or statesmen with whom they were dealing. The ratification by France of a treaty of peace with England in 1527 contains the illumination of a portrait of Francis I. It was ultimately discovered that a very fine piece of chicken skin stretched on a playing card made a better canvas than vellum alone.

Morgan's miniatures were mostly of notable historical European figures: royalties, courtiers, statesmen of the sixteenth, seventeenth, eighteenth, and early nineteenth centuries, including the work of such masters of the art as Hans Holbein, Nicholas Hilliard, Isaac Oliver, Richard Coswell, Jean Baptiste Isabey, and J.B. Jacques Augustin. Of the last named he had an unequaled selection, as he had purchased all of the widow's items.

One can readily see that to a man of Morgan's vivid historical imagination, a gallery of miniatures, very often painted from life, was an effective way of illuminating the past. His Holbein of Henry VIII may be the only existing portrait painted by the master of the lonely and megalomaniac monarch whom none loved and none dared disobey. The Windsor portrait of Henry is a copy of an original, and the Devonshire cartoon is the remnant of a larger picture. And Morgan's *Mary Queen of Scots* by an unknown artist must have been doubly precious to him for its provenance. Inscribed on the back are the initials CR, Carolus Rex, who was Charles I, grandson of the subject who, like her, lost his head.

Williamson has recorded what care his patron took in

The Annunciation
Follower of Rogier van der Weyden
Flemish, second half 15th c.
Tempera and oil on wood,
73¼ × 45¼ in.
The Metropolitan Museum of Art, New York, Gift of J. Pierpont Morgan, 1917.
17.190.1.

verifying the attributions of his miniatures. His adviser had to engage in months of research to convince him that one of his two Madame Du Barrys was the work of the Swedish painter Peter Adolf Hall, secretly commissioned by Gustavus III, who admired the French king's mistress and feared the jealousy of his own. And he delighted Morgan by establishing that one of his Marie Antoinettes had been flung out a window by a member of the mob ransacking the Tuileries. It was picked up in the street by a child who later became a governess in a noble English family. Ignorant of its worth, she gave the miniature to her wards as an ornament for their dollhouse where it was spotted and identified by no less a visitor than Queen Victoria!

The only miniature that Williamson himself sold to Morgan was one that he had identified as the wife of Dante Gabriel Rossetti, painted by the artist. It was owned by an impoverished lady who didn't know what she had and wanted to sell it to pay her doctor. Morgan, touched by the story, agreed to take it for a sum that ensured the owner a small annuity.

Williamson, who was always much in awe of Morgan, related how once he became so excited at the appearance on the auction market of a particularly fine miniature by Antoine Sergent of one of Marie Antoinette's ladies, later guillotined in the Terror, that he exclaimed to his patron: "You *must* buy it!" The gruff answer, reminiscent of the dying Queen Elizabeth's retort to Robert Cecil when he told her she must go to bed, was: "Must? Must? I shall buy it if I like it." But he bought it.

Acknowledgments

I am happy to acknowledge my gratitude for the help and assistance of the following generous persons: Charles E. Pierce, Frederick C. Schroeder, William Voelkle, and Inge Dupont at the Pierpont Morgan Library; Philippe de Montebello, Everett Fahy, James Parker, and Jeanie M. James at The Metropolitan Museum of Art; Linda Horvitz Roth at the Wadsworth Atheneum; Jean Strouse, author of a work in progress on the life of J. P. Morgan, and Mabel Satterlee Ingalls, his granddaughter.

Louis Auchincloss

Index

Pages on which illustrations appear are in *italics*.

Adam and Eve (Ibn Bakhtishu), *120*
Aeneid (Gruniger), 46, 47
Agnew, Sir William, 106
Agnew Galleries (London), 106
Agnus Dei and Symbols of the Evangelists, 33
Aldobrandini, Cardinal Pietro, 99
Aldobrandini Palace (Rome), 99
Alexandra, queen of England, 89–92
Alexandrinus, Didymus: "De Spiritu Santo,"
 123
Algiers (Algeria), 13
Allen, Frederick Lewis, 12, 13
American Academy (Rome), 96
Andrews, Wayne, 96–97
Angels with the Virgin at the Tomb, 26
Anne, queen of Austria: portrait of (Rubens),
 89
Anne of Denmark, consort of James I, 136
Annunciation (Belgian, 15th c.), *118*
Annunciation (Flemish, 15th c.), 136; *138*
Ansidei Madonna, 107
Antonio, Biagio di, workshop of (Florence):
 Scenes from the Story of the Argonauts,
 60–61
Apocalypse, 59
Apocalypse Cycle, 115
Apostles in Prayer: Pentecost, 38
Arms-Bearer of the King, 126
Ascension, 116
Ashburnham, earls of: collection of, 136
Ashur-nasir-apal II, king of Assyria, 127
Assyrian slabs, 127; *126–30*
Astronomical Table Clock, 65
Athens (Greece), 96
Augustin, J. B. Jacques, 139
Automaton: Diana and the Stag (Friess), *68*

Baca-Flor, Carlos: *J. Pierpont Morgan, 8*
Barthelemy, Claude: *Nurse with Child, 75*
Basin with the Arms of Castille, Leon, and
 France, 75
Beheading of John the Baptist, The, 70
Belisard, Claude Billard de, 79
Belle da Costa Greene (Helleu), *19*
Bembo, Bonifacio, 116; *Last Judgment, 125*;
 Sun, 125
Bening, Simon: *May, 121*
Bennett, Richard: collection of, 59–62
Bentley, John, 105
Berenson, Bernard, 114, 136
Berri, duc de, 42, 59
Bertin, Mademoiselle, 106
Betrayal of Christ in the Initial Q, The, 123
Bible, The, 112, 115

Biblical Scenes: Saul with the Army of Israel;
 Combat of David and Goliath; *David*
 Beheading Goliath; *Saul Attacking David*;
 David Anointed; *Killing of Absalom*; *David*
 Mourning Absalom, 112
Biron, Château de (Perigord), 43
Bismarck, Otto von, 107
Blanche of Castile and Her Son, Saint Louis:
 The Author and the Scribe, 115
Blue Boy, The (Gainsborough), 106
Bobillet, Etienne: *Mourners, 42*
Bode, Wilhelme von, 53
Bonheur, Rosa: *Horse Fair, 24*
Boston (Massachusetts), 12
British Museum (London), 53, 110, 127
Burlington Magazine, The, 13
Byzantine collection, 62–63, 110–11

Cambridge (Massachusetts), 106
Camilio. *See* Gambello
Carolus Rex, 139
Casket Plates: Joshua Condemning to Death
 Adoni-Zedec, King of Jerusalem; *Joshua*
 Overwhelming the Army of the Canaanites at
 Ai; *Joshua Receiving the Ambassadors of*
 Gideon, 28–29
Casket with Various Mythological Figures, 30
Caxton, William, 62; portrait of, 101
Cecil, Robert, 140
Cesnola, Palma di, 24
Chalice with Old and New Testament Figures and
 Scenes from the Passion, 46
Chalice with Personification of Rome, 27
Champlevé enamel, 110
Charles I, king of England, 139
Chasse or Reliquary with Crucifixion, Christ in
 Majesty, and Symbols of the Evangelists and
 Apostles, 35
Chavagnac, comte de, 53
Chicago (Illinois), 106
Chigi arms, 99
"Children's Hour, The" (Longfellow), 53–54
Christ Appearing to Magdalene, 116
Christ Blessing, Surrounded by a Donor and His
 Family (Ring), *44–45*
Christie's (London), 106, 139
Christ Seated on Calvary, Awaiting Crucifixion
 (Poyet), *122*
Civil War, The (1861–1865), 13–14
Cloisonné enamel, 110
Clovio, Giulio: *Creation, 124*
Clugny, Ferry de, 136
Coiny, Mathieu: *Snuffbox, 77*
Colonna Altarpiece, 107, 108
Constable, John, 85; *White Horse, The, 90–91*
Constantinople (Holy Roman Empire), 110

Corvinus, Matthias, king of Hungary, 123
Coswell, Richard, 139
Couch and Footstool, 24
Covered Cup, 65
Covered Vase for a Pot-Pourri, 84
CR. *See* Carolus Rex
Creation (Clovio), 124
Croker, Miss, 92; portrait of (Lawrence), 92, 93

Da Costa Hours, 121
David's Battle with Goliath, 26
Death of the Virgin, 70
De Forest, George B.: collection of, 59
De Forest, Robert W., 54, 71
Delmé, Lady Betty: portrait of (Reynolds), 105
Derby, Lady. *See* Farren
Desiderius Erasmus (Holbein), 81; *72*
"De Spiritu Sancto" (Alexandrinus), 123
Disraeli, Benjamin, 107
Don Pedro, Duque de Osuna (Goya), 94
Dover House (England), 67
Dresden Museum (Germany), 107
Drexel Morgan & Co. (New York), 14
Drey, A. S., 16
Dry masonry, 96
Du Barry, Madame, 131; portrait of (Hall), 140
Duchess of Devonshire, The (Gainsborough), 89, 105–106; *104*
Duke of Warwick (Van Dyck), 89
Duncan Sherman & Co. (New York), 13
Duomo, the (Florence), 85
Durlacher Brothers (London), 110

Early Louis XV Room (Vassé), 76
East Room Ceiling of the Pierpont Morgan Library, 101
East Room of the Pierpont Morgan Library (Stoller), 98
Education of the Virgin: Saint Anne and the Virgin as a Child, The, 44
Elizabeth, daughter of the 11th Lord Zouche, 136
Elizabeth I, queen of England, 136, 140
Ellis, Wynn, 105–106
Empoli (Italy), 99
Enamel collection, 110–11
English High School (Boston), 12
Enthroned Virgin, 35
Entombment with Donors, 43
Episcopal Church, The, 11, 12.
Erectheum (Athens), 96
Eugénie, empress of France, 107
Ewer (French, 16th c.), 57
Ewer (Italian, 16th c.), 58
Ewer Decorated in Grotesques in the Style of Berain, 84
Ewer of Zenobius, 27

Fall of Man, The, 73
Farnese, Cardinal Alessandro, 124
Farnese Hours (Monterchi), 124
Farnese Palace (Rome), 100
Farren, Miss: portrait of (Lawrence), 93, 105
Faun Playing the Flute (Gambello), *50*
Fayal (Azores), 12
Ferdinand, archduke of Austria: portrait of (Rubens), 89; *83*
Fillmore, President Millard, 12
Fiorentino. *See* Lunetti
Fitzhenry, J. H., 53
Fleet of Aeneas Arriving in Italy, 46

Florence (Italy), 16, 85
Fragonard, Jean-Honoré, 131; *Loves of the Shepherds: The Pursuit, The Meeting, Love Letters, The Lover Crowned*, 81, 131; *132–35*
Fragonard Room, 89
Francis I, king of France, 139
Francis I, king of the Two Sicilies, 107
Francis II, king of the Two Sicilies, 107
Frederick I Barbarossa, Holy Roman emperor, 110
Frick Collection (New York), 81, 131
Friess, Joachim: *Automaton: Diana and the Stag*, 68
Frontispiece with Medallion Depicting Saint Jerome at His Desk, Florence in the Background, and King Matthias Corvinus Kneeling at the Lower Left (Giovanni), 123
Fry, Roger, 23–24, 110–11

Gainsborough, Thomas, 85, 89, 105–106; *Blue Boy, The*, 106; *Duchess of Devonshire, The*, 89, 105–106; *104*; *Mrs. Tenant*, 105
Gallo-Roman collection, 62
Gambello, Vittore di Antonio: *Faun Playing the Flute*, 50
Gardner, Isabella Stewart, 136
Garland, James A.: collection of, 62
Garofalo, Benvenuto Tisi da: *Predella: Saint Nicholas of Tolentino Reviving the Birds*, 55
General John Burgoyne (Reynolds), 90
Genthe, Arnold, 99
George Peabody & Co. (London), 13
Georgiana, duchess of Devonshire, 105; portrait of (Gainsborough), 89, 105–106; *104*
Germanic collection, 62
Gherarducci, Silvestro dei: *Last Supper, in the Initial C*, 118
Ghirlandaio, Domenico: *Portrait of Giovanna Tornabuoni*, 16, 81; *20*
Gideon, Lady, portrait of (Gainsborough), 105
Gigli, Cardinal Ignazio, 99
Giovanni, Monte di: *Frontispiece with Medallion Depicting Saint Jerome at His Desk, Florence in the Background, and King Matthias Corvinus Kneeling at the Lower Left*, 123
Gloucester, duchess of: portrait of (Reynolds), 105
Godsal Children (Hoppner), 105
Golden Bowl, The (James), 56–59, 67
"Golden Gospels," 59
Gothic collection, 63–64
Göttingen, University of (Germany), 13
Goya, Francisco José de: *Don Pedro, Duque de Osuna*, 94
Graduale, The, 118
Grasse (France), 131
Greene, Belle da Costa, 18–21; and J. P. Morgan, 18, 21; as librarian, 16, 18–19; personality of, 18–21; portrait of (Helleu), 19; as purchaser, 16, 21, 53
Grenier, Pasquier, workshop of (Tournai): *Seven Sacraments Tapestry, The*, 36–37
Gruniger, Johann: *Aeneid*, 46, 47
Gustavus III, king of Sweden, 140
Gutenberg, Johann: portrait of, 101
Gutmann collection, 62
Guy Mannering, 14

Hall, Peter Adolf, 140
Hals, Frans, 89
Hamburger Frères (Paris), 114

Hamilton, duke of, 59
Hamilton, Lady: portrait of (Romney), 93, 105
Hamilton, William P. (son-in-law), 105
Hartford (Connecticut), 12, 54, 79
Helenus and Andromache Exchanging Gifts, 47
Helleu, Paul: *Belle da Costa Greene*, 19
Hellman, George S.: *Lanes of Memory*, 53–54
Henry VIII, king of England, 59; portrait of (Holbein), 139
Hercules (Pollaiuolo), 49
Hilliard, Nicholas, 139
Hobbema, Meindert, 85
Hoentschel, George: collection of, 62
Holbein, Hans, the Younger, 139; *Desiderius Erasmus*, 81; *72*
Honorable Henry Fane with His Guardians, Inigo Jones and Charles Blair (Reynolds), *81*
Hope (Reni), 13
Hoppner, John, 85; *Godsal Children*, 105
Horse Fair (Bonheur), 24
Huntington, Henry E., 106
Hyde Park (London), 85

Ibn Bakhtishu: *Adam and Eve*, 120
Illuminated manuscript collection, 111–16
Incredulity of Saint Thomas, 116
Institut Sillig (Vevey), 13
Irwin, Theodore: library of, 59
Isabey, Jean Baptiste, 139

James, Henry, 55–59, 67–71; *Golden Bowl, The*, 56–59, 67; *Outcry, The*, 56, 67–71
Jarves, James Jackson, 24
Jeweled Cover, 111; *113*
John Observes the Seven-Headed Beast of the Sea, 115
Johnson, Mrs. Scott: portrait of (Romney), 105
John the Evangelist, John the Baptist Preaching, Marriage Feast at Cana, 112
Joseph Receiving His Brothers in Egypt, 78
Journey to Emmaus, Noli Me Tangere, The, 34
J. Pierpont Morgan (Baca-Flor), 8
J. Pierpont Morgan as a Student at Vevey, 10
J. Pierpont Morgan Erupting at a Reporter, 15
J. P. Morgan & Co. (New York), 14

Kaendler, J. J.: *Meissen Group: The Judgment of Paris*, 87
Kaiser Friedrich Museum (Germany), 53

Lady Maitland (Raeburn), 105
Lady Writing, A (Vermeer), 54, 81; *25*
Laffan, William M., 53
Lallement, Guillaume, 122
Lallement Missal, 122
Lanes of Memory (Hellman), 53–54
Last Judgment (Bembo), 125
Last Supper, in the Initial C (Gherarducci), *118*
Lawrence, Sir Thomas: *Miss Croker*, 92, 93; *Miss Farren*, 93, 105
Lawrence, William, bishop of Massachusetts: memoirs of, 85–93
Layward, Austen Henry, 127
LeBreton, Gaston: collection of, 62
Lehmann, Robert, 81
Leo X, pope, 59
Lepaute Workshop (France): *Mantel Clock: The Triumph of Love over Time*, 78
"Library of Leather and Literature," 59
Lindau (Germany), 111
Lindau Gospels, 111, 113
Linden, Elias zur: *Ship with Silver Gilt Hull and*

Oval Base Embossed with Waves and Dolphins, 74
Lineage of Saint Anne (Pénicaud), 52
London (England), 12, 67, 71, 85–93, 106, 107, 110, 127, 131, 139
London *Times*, 67, 99
Longfellow, Henry Wadsworth: "Children's Hour, The," 53–54
Louis XV, king of France, 131
Louis XV Room, 89–92
Louis XVI Room, 89
Louveciennes, Château de (France), 131
Louvre, The (Paris), 131
Loves of the Shepherds: The Pursuit, The Meeting, Love Letters, The Lover Crowned (Fragonard), 81, 131; *132–35*
Lucca (Italy), 99
Lunetti, Tomasso di Stefano: *Portrait of a Man*, 58

Madame Delmé and Children (Reynolds), 85
Madonna and Child Enthroned, with Saints (Raphael), 107; *108*
Madrid (Spain), 107
Maginnis, Miss, 105
Manafi Al-Hayawan (Ibn Bakhtishu), 120
Mantegna, Andrea, circle of (Padua): *Nude Boy*, 49
Mantel Clock: The Triumph of Love over Time (Lepaute), 78
Manuel I Comnenus, Byzantine emperor, 110
Manuscripts. *See* Illuminated manuscript collection
Marfels collection, 62
Marie Antoinette, queen of France, 106, 140
Marlborough, Duke of, 107
Marriage of the Virgin: Eight Medallions with Scenes from Her Life, 119
Mary Magdalene, Saint: tooth of, 14; *17*
Mary Queen of Scots, 139
Masterpieces, 105–40
Matilda, contessa of Tuscany, 112
Maubert, Monsieur, 131
Maucher, Christopher: *Tankard with the Queen of Sheba Before Solomon*, 73
May (Bening), *121*
Mazarin Tapestry with the Triumph of Christ, The, 81; *48*
McKim, Charles, 55, 96, 99
McKim, Mead & White, 96; *Perspective Proposal for the Pierpont Morgan Library*, 96–97
Medieval collection, 63–64
Meissen Group: The Judgment of Paris (Kaendler), 87
Memling, Hans, 136
Merovingian collection, 62
Metropolitan Museum of Art, The: and J. P. Morgan, 23–30, 71, 79, 81, 127; Morgan Wing, 71–75; 88–89
Metropolitan Museum of Art *Bulletin*, The (February 1912), 71
Micaud, Jacques-François: *Tea Set*, 87
Michelangelo, 63
Milan (Italy), 114
Miniature collection, 89, 114, 139–40
Miss Croker (Lawrence), 92, 93
Miss Farren (Lawrence), 93, 105
Miss Rose (Raeburn), 105
Monterchi, Francesco: *Farnese Hours*, 124
Morgan, Anne (daughter), 105
Morgan, John Pierpont: birth of, 12, 101; as

Brother Libra, 102; business career of, 13–14; card games of, 9, 16, 114; children of, 79, 105; as collector, 12–13, 14–16, 53–65; death of, 102; education of, 12, 13; father of, 12, 13, 14, 92, 106; as financier, 9–16; health of, 12, 13–14, 15; as inspiration to Henry James, 56–59, 67–71; knowledge of medieval calendars, 100–101; languages of, 13, 16; library of, 14, 16, 21, 96–102; marriages of, 13, 14, 102; at The Metropolitan Museum of Art, 23–30, 71–75; mother of, 12, 89; objective of as collector, 54–56, 79; personality of, 9–11, 15; portraits of, *2* (Steichen), *8* (Baca-Flor), *10, 15*; preferences of, 15; purchasing procedure of, 16, 53–54, 140; religion of, 11, 15; residences of, 10–11, 67, 85–93; as trustee-benefactor, 24; will of, 74–75, 79–81; zodiacal signs of, 101–102
Morgan, John Pierpont, Jr. (son), 21, 74–75, 79, 102, 105, 127, 139
Morgan, Juliet (daughter), 105
Morgan, Junius Spencer (father), 12, 13, 14, 106; portrait of, 92
Morgan, Junius Spencer (nephew), 18, 111
Morgan, Louisa (daughter), 105
Morgan collection, 53–75, 105–40; bequest of, 74–75; chronology of, 62–65; enamels in, 110–11; exhibition of, 75; *92–93*; illuminated manuscripts in, 111–16; masterpieces of, 105–40; miniatures in, 89, 114, 139–40; partial listing of collections purchased, 59–62; transmission of to New York (1912), 56, 67–71
Morgan Collection Exhibited at The Metropolitan Museum of Art, New York, 1914, 92–93
Morgan Cup, The, 21
Morgan Library. *See* Pierpont Morgan Library
Morgan Wing at The Metropolitan Museum of Art, New York, The, 88–89
Morris, William: library of, 62
Mosan art, 110
Mosselman, Paul: *Mourners*, 42
Mourners (Bobillet and Mosselman), 42
Mowbray, Henry Siddons, 55, 96–97, 99–100
Mrs. Tenant (Gainsborough), 105
Mund, Georg: *Nautilus Goblet*, 69
Murray, Fairfax: collection of, 62
Murray Hill (New York), 14

Nana (Zola), 12
National Gallery (London), 107
National Gallery of Art (Washington), 54, 81
Nautilus Goblet (Mund), 69
Neptune on a Sea Monster (Ravenna), *51*
New Deal, 10
Newport (Rhode Island), 11
New York (New York), 13, 14, 23–30, 56, 67–71, 96–102
New York Public Library, The (New York), 96
New York *Sun*, 53
Nicolaes Ruts (Rembrandt), 80
Notable American Women, 1607–1950, 18
Nude Boy (Mantegna), 49
Nurse with Child (Barthelemy), 75

Ognissanti refectory (Florence), 16
Oliver, Isaac, 139
Outcry, The (James), 56, 67–71
Oval Basket, 86
Oval Chestnut Basket with Cover and Attached Stand, 86

Pajou, Augustin, 79
Panel of Wall Tiles, 41
Panic of 1907, 9, 54, 114
Paris (France), 85, 107, 114, 131, 140
Peabody, George, 13
Pénicaud, Jean II, workshop of (France): *Lineage of Saint Anne*, 52
Pentecost, 116
Perry, Marsden J.: collection of, 62
Perspective Proposal for the Pierpont Morgan Library (McKim, Mead & White), 96–97
Perugia (Italy), 107
Phillips, Jack ("Junka"), 106
Pierpont, John (grandfather), 12
Pierpont Morgan Library, 96–102; and Belle Greene, 16, 18–19, 21; building of, 55, 96–99; *96–98*; East Room, 97, 99; *98*; East Room ceiling, 99–102; *101*; West Room, 97–99; *100*; West Room ceiling, 99
Pietà with Donors, 43
Pinturicchio, 100
Pollaiuolo, Antonio: *Hercules*, 49
Portrait of a Lady, 137
Portrait of a Man (Lunetti), 58
Portrait of Giovanna Tornabuoni (Ghirlandaio), 16, 81; *20*
Portrait of J. Pierpont Morgan (Steichen), *2*
Portrait of the Archduke Ferdinand (Rubens), 89; *83*
Potter, Edward Clark, 96
Poyet, Jean: *Christ Seated on Calvary, Awaiting Crucifixion*, 122
Predella: Saint Nicholas of Tolentino Reviving the Birds (Garofalo), 55
Prince's Gate (London), 67, 85–93
Princeton (New Jersey), 18
Princeton University Library (New Jersey), 18
Processional Cross, 32
Proud Possessors, The (Saarinen), 27–30, 55
Psalter of Ramsey Abbey, 116

Queen Tomyris with the Head of Cyrus (Ravenna), *51*

Raeburn, Sir Henry, 89; *Lady Maitland*, 105; *Miss Rose*, 105
Raphael, 107; *Madonna and Child Enthroned, with Saints*, 107; *108*
Ravenna, Severo da: *Neptune on a Sea Monster*, *51*; *Queen Tomyris with the Head of Cyrus*, *51*
Read, Sir Charles Hercules, 53, 110
Reattributions, 136
Reliquary Monstrance with Tooth of Saint Mary Magdalene, 14; *17*
Rembrandt van Rijn, 59, 89; *Nicolaes Ruts*, 80
Reni, Guido: *Hope*, 13
Reynolds, Sir Joshua, 105; *General John Burgoyne*, 90; *Honorable Henry Fane with His Guardians, Inigo Jones and Charles Blair*, 81; *Madame Delmé and Children*, 85
Richmond (Virginia), 18
Richter, Jean Louis: *Snuffbox*, 77
Ring, Ludger Tom, the Younger: *Christ Blessing, Surrounded by a Donor and His Family*, 44–45
Robert, Hubert: *Swing, The*, 82
Robinson, Edward, 71
Rogier van der Weyden, 136
Rome (Italy), 13, 96, 99, 100, 107
Romney, George, 85, 93, 105
Roosevelt, President Theodore, 9
Rosetti, Dante Gabriel, 140

Roth, Lawrence, 18, 19
Roth, Linda Horvitz, 54–55
Rubens, Peter Paul, 89; *Portrait of the Archduke Ferdinand*, 89; *83*

Saarinen, Aline B.: *Proud Possessors, The*, 27–30, 55
Saint Bridget of Sweden, 66
Saint Christopher and the Christ Child, 39
Sainte Chapelle (Paris), 85
Saint Emerentia with Virgin and Child and Saint Anne, 66
Saint Jerome in His Study, 44
Saint John Baptizing (Sangallo), 50
Saint Paul, 22
Saint Peter, 22
Saint Stephen, Convent of (Empoli), 99
Saint Swithin's Priory (Winchester), 112
Samson and the Philistines, 63
Sangallo, Francesco de: *Saint John Baptizing*, 50
Sanitary Commission Fair (1864), 14
San Salvador de Fuentes, Church of (Asturias), 32
Santa Maria del Popolo, Church of (Rome), 100
Sant'Antonio di Padova, Convent of (Perugia), 107
Santi. *See* Raphael
Sanzio. *See* Raphael
Sardou, Victorien, 131
Satterlee, Herbert (son-in-law), 11–12, 105
Sawfish Flying over a Boat, 117
Scenes from the Story of the Argonauts (Antonio), 60–61
Scotland Yard (London), 106
Sergent, Antoïne, 140
Seven-Headed Dragon Attacked by the Family of the Woman, The, 115
Seven Sacraments Tapestry, The, 36–37
Sforza, Francesco, 114
Sheffield, earl of: collection of, 136
Sherman Act (1890), 9, 10
Ship with Silver Gilt Hull and Oval Base Embossed with Waves and Dolphins (Linden), 74
Snuffboxes, 77

Soeterbeeck, Cloister of (Germany), 66
Standing Cup with Cover, 74
Stavelot, Imperial Benedictine Abbey of (Belgium), 110
Stavelot Triptych, The, 110–11; *109*
Steichen, Edward: *Portrait of J. Pierpont Morgan*, 2
Stillwell, Margaret Bingham, 19–21
Stoller, Ezra: *East Room of the Pierpont Morgan Library*, 99; *98*; *West Room of the Pierpont Morgan Library*, 100
Sturges, Amelia ("Mimi") (first wife), 13, 14, 56, 102
Sturges, Jonathan, 56
Sun (Bembo), *125*
Sussex (England), 136
Swing, The (Robert), 82

Talbot, Mrs., 93
Tankard with the Queen of Sheba before Solomon (Maucher), 73
Tarot cards, 114–16. *See also* Visconti-Sforza cards
Taylor, Francis Henry, 12–13, 14, 16, 54
Tea Set (Micaud), 87
Thyssen, Baron, 81
Toovey, James: library of, 59
Tornabuoni, Giovanna: portrait of, 16, 81; *20*
Tournai (Belgium), 136
Tracy, Frances Louisa (second wife), 14, 102
Triple Choir Stall, 40
Tuileries, The (Paris), 140
Turner, Joseph, 89

Uses of Animals. *See Manafi Al-Hayawan*

Vanderbilt, Cornelius, II, 24
Van Dyck, Sir Anthony: *Duke of Warwick*, 89; *Woman in Red and Child*, 89
Vase, 64
Vassé, François-Antoine: *Early Louis XV Room*, 76
Velásquez, Diego, 89
Vermeer, Johannes: *Lady Writing, A*, 54, 81; *25*

Vevey (Switzerland), 10, 13
Victoria, queen of England, 107, 140
Victoria and Albert Museum (London), 67, 71
View of the Old Pierpont Morgan Library Building Looking Northwest from Park Avenue, 98
Villa Giulia (Italy), 96
Virgin and Child (Byzantine, 11th c.), *31*
Virgin and Child (French, c. 1270–1280), *35*
Virgin and Saint John, The, 29
Virgin Mourning, The, 39
Visconti, Bianca Maria, 114
Visconti-Sforza cards, 114–16; *125*
Voelkle, William, 100–102, 111–14

Wadsworth Atheneum (Hartford), 54, 79
Wakeman, S. H., 53; collection of, 62
Ward, Humphrey, 54
Ward, John: collection of, 62
Washington (District of Columbia), 54, 81
Watch Case Depicting Joseph and Potiphar's Wife, 77
Wertheimer's (London), 131
West Room of the Pierpont Morgan Library (Stoller), 100
White Horse, The (Constable), 90–91
Wibald, abbot of Stavelot, 110
Wildenstein, Georges, 131
Wilfred, archbishop of York, 59
Williamson, Dr. George C., 53, 139–40
Willoughby, Miss: portrait of (Gainsborough), 105
Windmill Psalter, 123
Winged Being Pollinating the Sacred Tree, 127–29
Winged Being Worshiping, 128, 130
Woman in Red and Child (Van Dyck), 89
Woolf, Virginia, 23
Workshop Bestiary, The, 117
Worth, Adam, 106

Zodiacal signs, 100–102
Zodiac of 12 (New York), 102
Zola, Emile: *Nana*, 12

Photograph credits
Frontispiece: reprinted with permission of Joanna T. Steichen © Edward Steichen, 1903; p. 15: courtesy of Culver Pictures; p. 98 (above and below) and pp. 100 and 101: courtesy of the Morgan Library